PAINTED CITIES

PAINTED CITIES

ILLUSTRATED STREET ART AROUND THE WORLD

LORNA BROWN

HEAD
of ZEUS

AN ANIMA BOOK

CONTENTS

INTRODUCTION 002

BETHLEHEM, PALESTINE 004

CAIRO, EGYPT 016

MELBOURNE, AUSTRALIA 026

CHRISTCHURCH, NEW ZEALAND 038

NEW YORK, USA 052

LOS ANGELES, USA 062

DETROIT, USA 074

LONDON, UK 084

BRISTOL, UK 098

HELSINKI, FINLAND 110

BERLIN, GERMANY 116

INTRODUCTION

I never intended to create a book about street art. Through painting buildings and architecture, street art had become an incidental motif within my work. The buildings I was drawn to and found visually appealing were the dusty ones, the dilapidated ones, the tired ones – the exact same buildings in the same parts of town that welcomed the street artists. Yet, by replicating the street art on my version of painted walls, something strange and new happened: the art and the place became unified through the watercolour washes. No longer paint on brick, but the representation of paint on brick through paint on paint.

Whenever I had seen photos of street art and graffiti in the past, they were so often cropped in tightly, placing all the emphasis on the art or writing itself, yet simultaneously missing what made the work different from paint on canvas. They were lacking context and environment – a critical part of the story.

And so began my slow exploration of this context, through eleven cities around the world. I noticed the universal elements that tied painting on walls together, as well as identified some of the place-specific influences that directed the work.

This is the first tentative step in trying to understand the world a little better by looking at the writing on the wall.

I gained a respect and understanding of graffiti writing over the months, even though it had been brightly coloured murals that gained my attention in the beginning.

Each trip to a new city would involve walking, skating or biking around, camera in hand, shooting reference photos and absorbing the place. I would talk to locals and go on art tours, drive around with graffiti writers and hear stories of each city. Occasionally, I would head out on a quest to find a specific piece, like a treasure hunt. Sometimes I would find what I was looking for, and sometimes I would not.

I had intended to include Belfast in this book, but life had other plans. My bag, containing most of my possessions, all of my handwritten research, my passport, vast quantities of reference photographs and all my essays, was stolen on the way to the airport to fly there. Belfast would have to take a back seat as I began the process of piecing the project back together from scraps.

I would then hole up somewhere in the world to paint from the reference I had gathered. For a while this was my studio in London, but the need to extract myself from life to finish the project dropped me in Malmo, Sweden where I painted, reflected, wrote and skated.

Henri Cartier-Bresson said, 'Photography is an immediate reaction, drawing is a meditation.' My painting encapsulates both of these concepts. The collection of reference photography froze the moment in the life of the wall; the works that sat on it at that time and on that day; the state of decay of the building and how many windows were smashed. Then the slow process of construction lines, perspective grids, inking and painting allowed my mind to sit inside that moment for hours, meditating on its significance, holding on to it – every corner explored with my eyes.

They say that the more you know about something, the more you know you don't know. This book is a collection of moments and meditations on these places, yet at the end of this set of travels I realized that I had barely scratched the surface and could probably spend a lifetime visiting a thousand cities to hear a thousand stories. This is, therefore, just the beginning. It is in no way comprehensive, but the first tentative step in trying to understand the world a little better by looking at the writing on the wall.

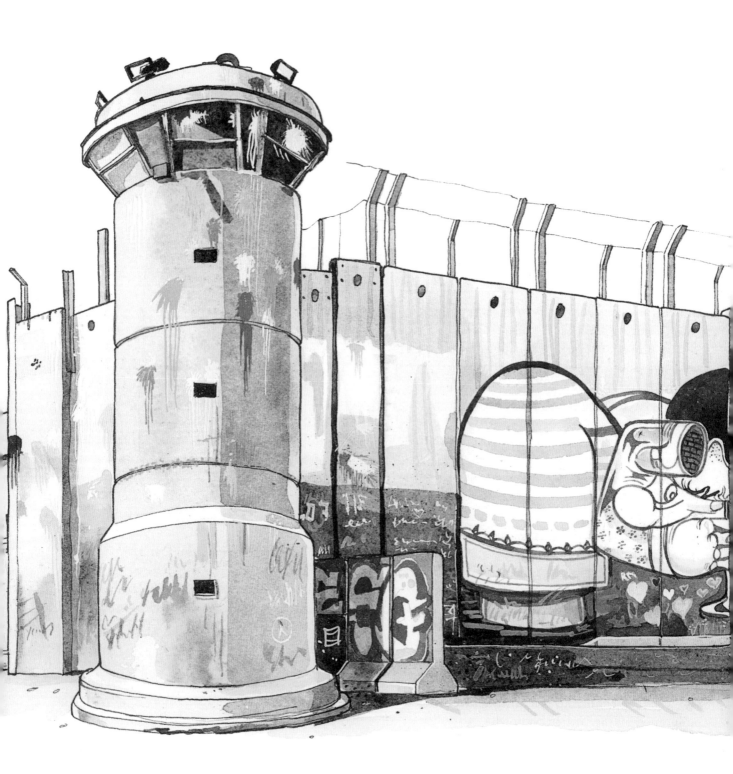

BETHLEHEM
PALESTINE

It all began in Palestine, in a small village outside of the city of Nablus, where I was volunteering for the skateboarding charity SkatePal in 2016. For the weeks I was living there, I used all my time outside of teaching the children how to skateboard, to travel around and experience as much of this unique place as possible. The buildings and structures of the occupation held particular interest for me: the concrete blocks surrounding bus stops, put in place to deter car-ramming attacks on Israeli settlers; watchtowers along all the major roads containing heavily armed soldiers of the Israel Defence Forces; tall wire fences surrounded Israeli settlement areas and, perhaps most famous of all, was the wall.

The separation wall was an imposing feature that cleaved the land in two. It stood nearly 8 metres (2.25 ft) high at points, constructed of solid concrete, and cast long shadows on to the land. Preventing free movement between the West Bank and Israel, the construction of the wall began after the Second Intifada of 2000, as a security measure following the subsequent wave of violence. It used the demarcation line known as the Green Line, drawn up in 1949 between Israel and its neighbours, as a guide. The Green Line was never intended to be an international boundary, which made the route the wall followed a complicated and controversial one. A 2009 report by the United Nations noted that the route the wall took annexed a total of 9.5 per cent of Palestinian land to the Israeli side. Separating farmers from their land, towns from their wells, and splitting communities, it has been condemned by the United Nations.

It was no surprise that, at points along the wall throughout Palestine, artists had been using it as a canvas to express themselves, to repurpose and subvert it, to retake ownership of the environment. I visited the wall at several points – Tulkarm in the north; the enclave of Qalqilya where the wall wraps almost completely around the city leaving just a narrow entry point; and Bethlehem, located to the south of Jerusalem.

Of all the locations, it was Bethlehem where the drips of graffiti had turned into a tsunami. Street artists from around the world had travelled to the wall to paint – artists whose work I would see in other cities on my journey following the story of painted cities: How and Nosm, Lushsux and, most famously of all, Banksy.

From my many conversations with Palestinians living in the West Bank, the predominant message was one of wanting to be heard by the world beyond the wall. There was a strong feeling of isolation, of being forgotten and ignored. Powerless. The internationally renowned artists choosing to shine a spotlight on the wall and the politics of the area, bringing the eyes of the world upon this place, had the ability to address this. The juxtaposition of world-famous works butting up next to the work of local artists, in addition to the messages left by visiting tourists, is striking – part 'this is my story' and part 'we hear you'.

When I visited, it was estimated that street art tourism brought in more tourists than religious tourism to the city of Bethlehem. It was a tangible way in which the writing on the wall had given

Of all the locations, it was Bethlehem where the drips of graffiti had turned into a tsunami.

practical help to a community that had suffered under the image of it being too dangerous a place to visit. Multiple 'Official Banksy' shops were sprinkled around, created by entrepreneurial locals. As we walked the streets, a young Palestinian boy was chasing and yelling at another boy, waving a broom in the air above his head as he did so. It turned out that the one being chased had burst all of the balloons outside of his 'Official Banksy' shop. As we stepped inside, the young boy with the broom came back in to his tiny space, greeted us with a smile and gave us some biscuits. There was an original Banksy piece sprayed on the wall and protected with a sheet of Perspex, the shop erected around it selling snacks and drinks but also postcards and magnets featuring the more famous street art pieces of the city. I talked to him for a while, a little in Arabic and a little in English, bought a magnet and some postcards and left him to replacing the balloons.

Around the corner I found another Banksy-themed shop that sold spray cans in Palestinian red, green and black colours so that tourists could add their own messages to the wall. This had the effect of covering some of the more intricate street art pieces with scrawled names and supportive slogans. The volume of tags held a visual significance that was more powerful than aesthetics. Offering solidarity to people who felt forgotten, it was a reminder that they were not. I walked past the Walled Off Hotel under construction, another Banksy project that

would reignite international interest in the area.

The wall was not just for visitors, it was also used as a way of letting local voices be heard. Along one stretch, white posters had been put up containing a series of written personal accounts from Palestinians living under its shadow – stories of tear gas and heartbreak. Another area had been painted white and was used as the backdrop for the projection of football games that the community could gather around, the huge surfaces of the wall converted into a giant TV screen. One of the most famous characters depicted on the wall at different points was the product of the Palestinian cartoonist Naji Salim Hussain al-Ali. The cartoonist created the image of a boy he named Handala, which became an icon of Palestinian defiance. Naji al-Ali was killed in 1987, but the spiky-haired character is still being painted in public.

Within Bethlehem, the painted walls were not limited to the towering separation wall. Aida Camp, the Bethlehem refugee camp created in 1950 to house refugees from Jerusalem and Hebron, covered a small area and was severely overcrowded. I had already visited a large refugee camp in Nablus called Camp No. 1, and been shown around the tight, dark alleyways of towering concrete buildings. The footprint of the refugee camps was not permitted to expand since their creation in 1950 so, to accommodate the growing population as new generations were born, the only place for the buildings to expand was vertically. At some points, the passageways were so tight that it was easy to

touch both buildings on either side at once. Bullet holes peppered the walls, and I felt claustrophobic thinking of the regular raids by the Israeli military. I imagined the panic of being tear-gassed in a labyrinthine place.

I had also been staying in a hostel located in the centre of another refugee camp in Jericho, where the streets were wider and brighter and the place more closely resembled a small village. A number of shops were scattered around and there was an excellent falafel truck near the entrance to the camp where we ate each night.

The physical characteristics of Aida Camp were somewhere in-between these two versions. The Bethlehem refugee camp contained two schools, and the route to these schools was decorated with bright murals featuring colourful cartoon characters. They carried messages that reminded residents to resist, to be fierce, whilst simultaneously splashing colour in what would be a bleak concrete-and-dust environment. I walked by a wall with 'We Will

Return' painted on it, below which were the names of the towns and cities that the refugees fled from in 1950. The attachment to the past whilst keeping hope for the future was one of the trickiest aspects of the political situation in this part of the world, and it was this dichotomy that was a regular theme on the walls. There wasn't a clear answer to the problems people here faced, but for those who felt powerless, the ability to express themselves was a powerful outlet.

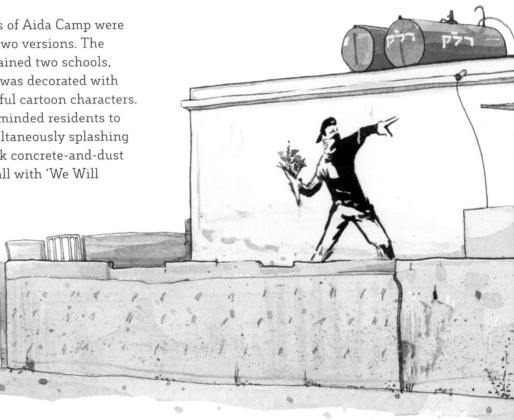

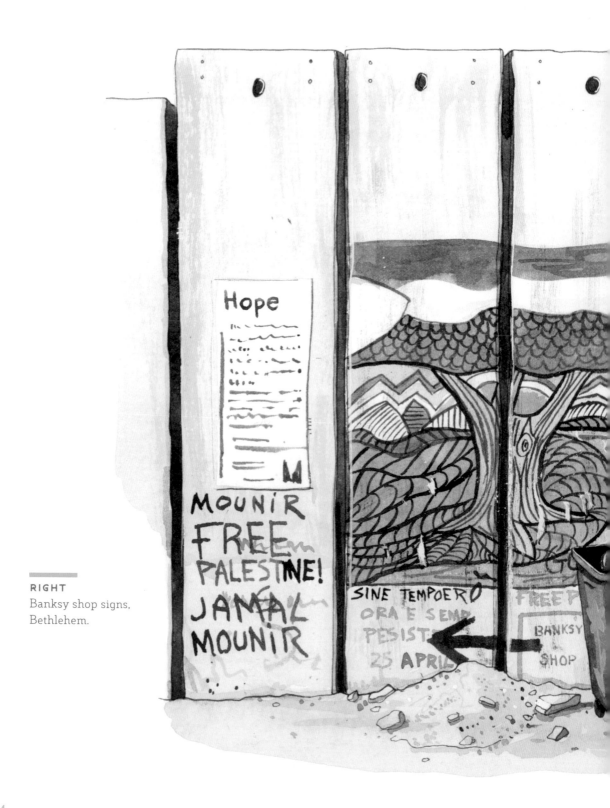

RIGHT
Banksy shop signs,
Bethlehem.

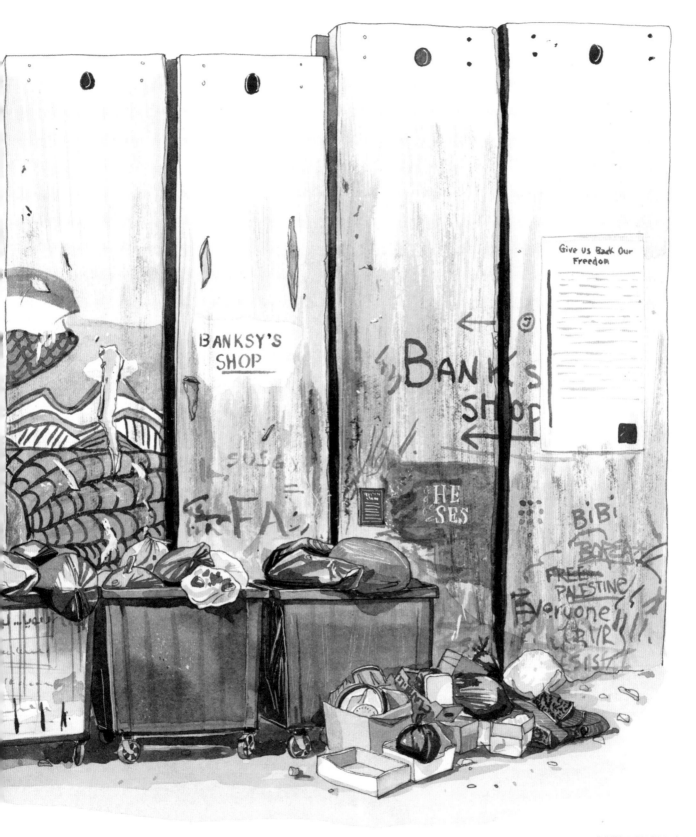

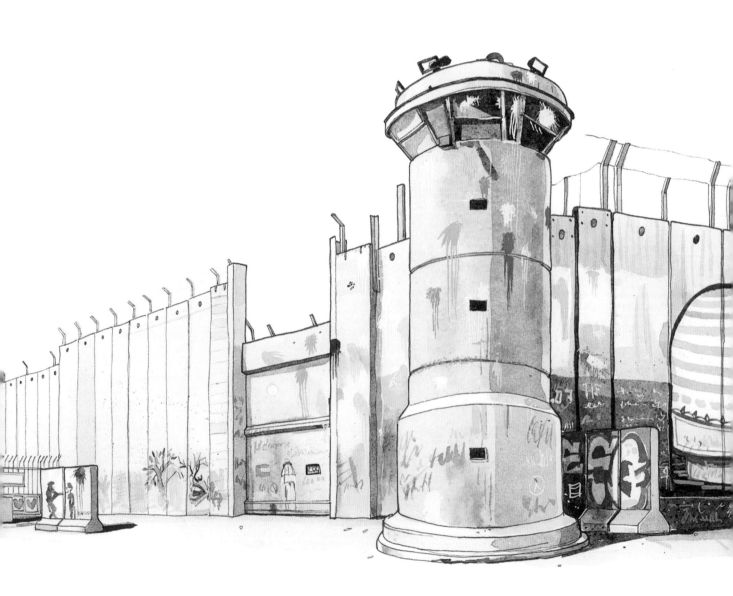

How n Nosm, separation wall
and tower, Bethlehem.

The juxtaposition of world-famous works butting up next to the work of local artists, in addition to the messages left by visiting tourists, is striking — part 'this is my story' and part 'we hear you'.

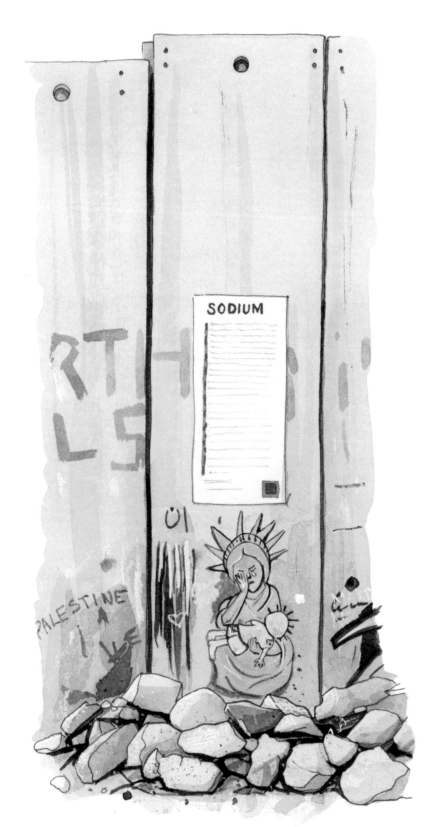

LEFT
Liberty and Handala,
separation wall, Bethlehem.

RIGHT
Here, Only Tiger Can Survive.
Aida Camp, Bethlehem.

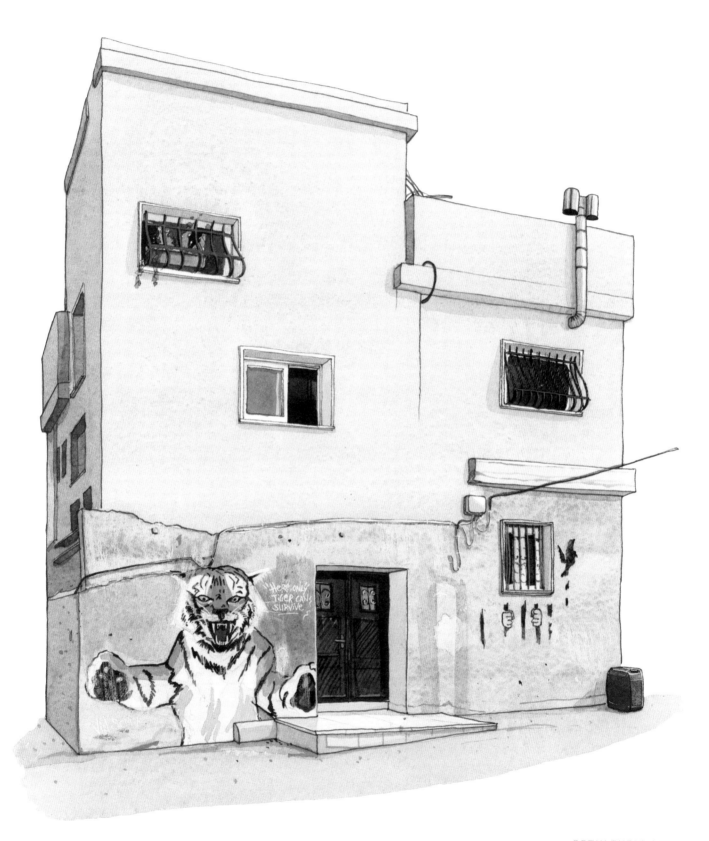

CAIRO
EGYPT

Flying into Cairo I was struck by the sprawling expanse of the place. Peering out of my plane window I could see mile upon mile of sandy coloured high-rise buildings, carved up with curving and sweeping highways, all lined with giant billboards. Homes were stacked one upon another, reaching into the sky. There was a population of more than 20 million people in Greater Cairo alone, and it was densely packed.

I was travelling with my journalist friend, Jess, on this trip and we were staying with one of her Cairene friends, Laila, who lived in a stylish compound in the northeast of the city. Driving along in our cab, it felt good to be back in an Arabic country. I enjoyed the noise, the smells, the sounds, the traffic, the chaotic atmosphere and the familiar strangeness of it all.

On 25 January 2011, an uprising began in Egypt. It was the culmination of growing tension between the politically active youth movement and the established rulers. Millions of protesters took to the streets across the country to demand the overthrow of the Egyptian president, Hosni Mubarak, who had been in power since 1981. During the eighteen days of protests more than 800 people were killed and over 6,000 were injured. On 11 February 2011, Mubarak resigned as president. Whilst the protesters may have won this battle, the war was far from over. The power vacuum that followed, along with the collective grief of the people, did not bring about the Egypt that so many dreamed of. Too complex were the systems that needed overhauling following nearly thirty years of Mubarak's rule.

The uprising was named a 'Facebook revolution', thanks to the use of social media as a form of mobilizing the youth. (There were similarly organized uprisings in Iran, Tunisia, Ukraine and Romania.) The power of young people working together to have their voices heard put a spotlight on the ways in which they communicate and resulted in street art within Cairo being seen as a political act. Even photographing street art in Cairo could land you in trouble – I had heard stories of photographers and journalists being asked to report to the authorities for doing exactly that. The city's tough stance on graffiti brought to mind the Banksy piece in London from April 2011, not long after the Egyptian uprising, that said 'If graffiti changed anything it would be illegal'.

The power of the younger population was not dismissed here. Art as a force to mobilize large groups of people was not underestimated. I wandered the streets and found very little sprayed upon the walls. Laila told me that anything painted on any of the buildings was usually buffed over very quickly. I passed one such wall that I knew was a prime location for pieces, but it was freshly painted and completely blank.

Mohamed Mahmoud Street, near Tahrir Square, was the location of several of the more violent battles between protesters and the security forces and one of the few places that contained street art as a memorial to the clashes. I shot my reference of the work that was there as stealthily as possible, carrying my camera at my hip rather than my face, casually holding a conversation with Jess and Laila

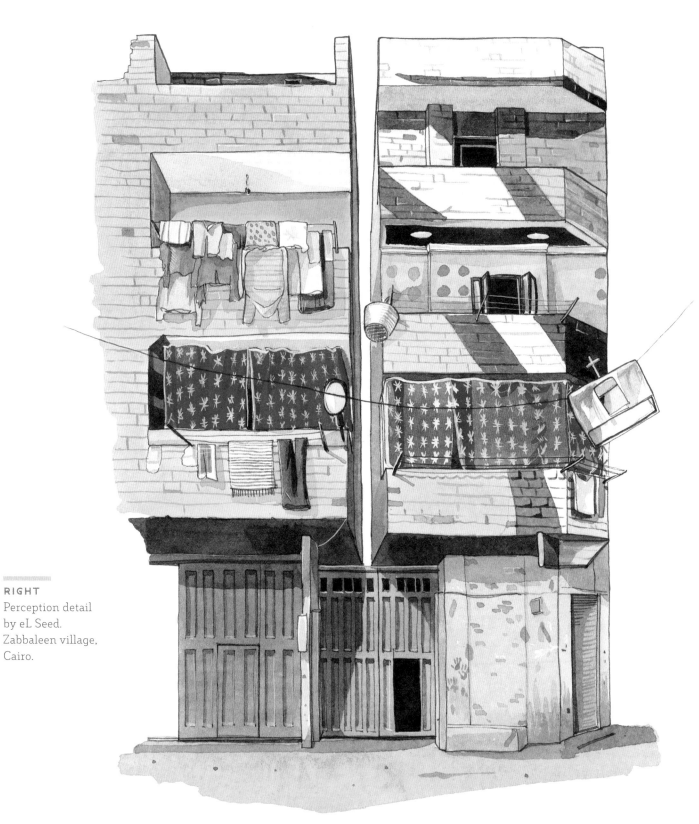

RIGHT
Perception detail
by eL Seed.
Zabbaleen village,
Cairo.

as I did so. The murals covered a long wall of what used to be the American University in Cairo (the Campus had moved), and across the street on the walls of the GrEEK Campus, previously part of the university but now home to tech and start-up businesses. Most of the murals were residual works from the 2011 to 2013 period. Hot sunshine had bleached the vivid blood reds of the paint to soft pinks, and the paste-ups were peeling and flaking. It felt allegorical of the uprising that had burnt so fiercely with many people dying on the streets, to where it was now, an undercurrent of glowing embers of disappointment and resignation; peace on the streets but not quite business as usual.

I walked the streets, dodging between five lanes of traffic as if I was in an advanced level of the Eighties computer game, Frogger. It was only after walking the streets for a long time that I started to tune in to the Martyr stencils. Scattered across the city, there were small stencil images of the faces of different people who had died or been injured during the revolution, often paired with Arabic phrases that Laila translated for me. 'I am the evidence. I am the eye that was hit by fate and bled to death' was one such phrase sprayed in red on the wall of a dilapidated print shop below an icon of a man with blood exploding from his eye socket. These Martyr stencils may have been subtle and small but they were fast enough to produce that they could be sprayed in large numbers, and the stencil format allowed multiple people to bomb the city in a single night – an example of the message being more important than the messenger. Cairenes

were going about their business beneath them, occasionally catching a glimpse of a stencilled face reminding them that the fires of the past could not be completely extinguished or forgotten.

Having collected what I could from the centre of Cairo, I set off on a mission to find the multi-building mural called 'Perception', by the artist eL Seed, which he had completed in 2016. The piece was spread over almost fifty buildings within the Coptic community of Zabbaleen people in Mokattam Village below the Mokattam Mountain. Zabbaleen means 'garbage people' and they were given this name because of the important role they played in sorting through Cairo's rubbish.

Laila helped me to hire a local artist couple to drive me to find and collect reference material of the piece. They arrived at the designated meeting point in a beaten-up white car. I climbed into the back seat and was greeted by a small kitten that they had rescued and who now lived in the car. The kitten, Dot, promptly curled up in my lap and fell asleep. We set off driving, with only the vaguest idea of where we were going. We had thought that a mural painted across fifty buildings would be an easy spot from the Mokattam Mountain, and an hour of driving later pulled up to a place where the mountains overlooked the high-rise buildings below. Looking out over the density of the city, I realized that the task of finding a vantage point of the mural might be harder than anticipated. We walked for a while along a dirt path that wrapped around the edge of the mountains, and I searched the surfaces of all of the buildings for any signs of the primary

colours left by the hand of eL Seed. On the horizon I could just make out the Great Pyramids, blurry and indistinct thanks to the smoggy Cairo air. After some time hunting with no success, like a real-life Where's Wally? book, we went back to the car and carried on the search elsewhere. We followed clue after clue for hours; my guides asked everyone they knew. One such clue came in the form of: 'Find the church; the cafe above the church is where you can view it from. Ask for the cafe owner and he will let you in.' There was no mention of which church, so we went to the one that my friends knew about – we found a cafe and it was locked. I could hear in their voices as they spoke to each other in Arabic that they were starting to panic. Whenever I asked if everything was OK, they turned and smiled and answered happily in English that everything was fine and we'd just try the next place. Eventually we reached a point late in the day when we all stopped where we were, all clues were exhausted, the sun getting lower in the sky. They looked at me and admitted that we were all out of leads. We headed back to the car that was parked by Tahrir Square. Back in the Cairo traffic, heading in the direction of the mountains again, their phone rang. It was an artist friend with another tip-off for the location to view the eL Seed piece from. Hope filled the car again and we drove back out of the city. This was our last chance. If this lead didn't take us there, there would not be enough light to shoot the reference I needed to do the paintings, and I was flying back to London early the next day.

We drove up to the cave monasteries set into the side of the mountains, the roads narrowing the higher up we got, lined with towering piles of rubbish as we passed by the tiny openings to the maze that was the Zabbaleen village. We jumped out of the car and headed straight to the cafe. The young woman serving at the cafe window downstairs told us that upstairs was closed – but we hadn't come this far to only come this far. We walked up a spiral staircase on the outside of the building and reached the locked door to the upstairs area. We knocked and waited. An old man answered, listened to our story and let us in. I followed behind him as we walked through the room and into another smaller room where all of the blinds were closed. At the very end of this room he opened a blind and the window. I stepped out from behind him, my heart beating hard. The view hit me: there it was, more breath-taking and incredible than I had even imagined. Lit up by the golden light of the low sun, narrated by the sounds of children calling pigeons back home to roost in the towers scattered across the rooftops, I folded in half and cried at the perfection of it. After so much heartbreak and sorrow following the story of the revolution, this expression of hope was the sweetest of tonics.

The power of the younger population was not dismissed here. Art as a force to mobilize large groups of people was not underestimated.

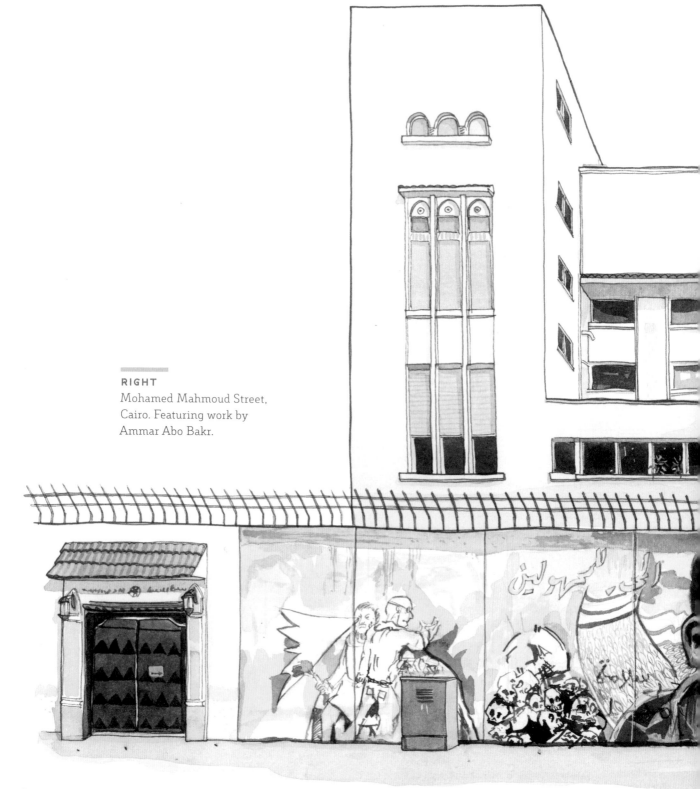

RIGHT
Mohamed Mahmoud Street,
Cairo. Featuring work by
Ammar Abo Bakr.

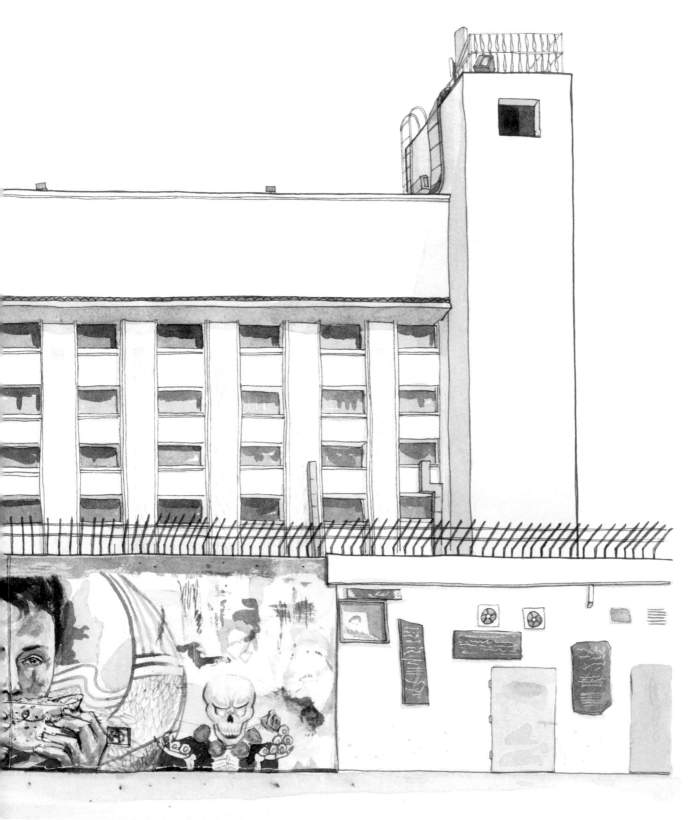

My eyes filled
with tears as the
low sun in the sky
cast magnificent
orange light across
the brightly painted
buildings bearing
the work I had spent
all day searching for.

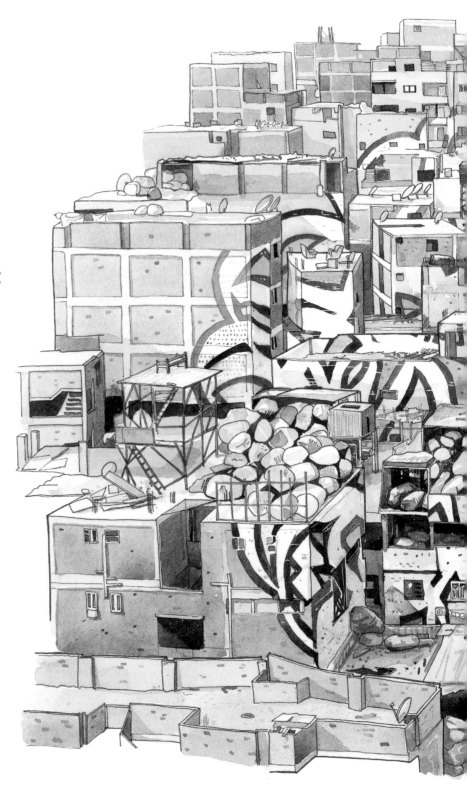

RIGHT
Perception by eL Seed.
Zabbaleen village, Cairo.

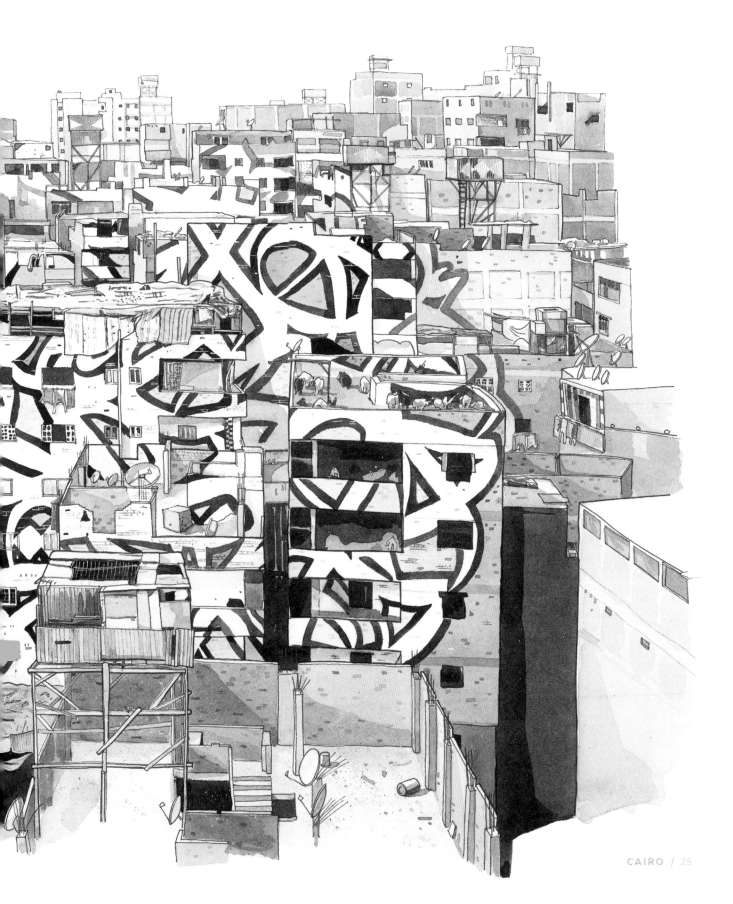

MELBOURNE
AUSTRALIA

Nothing made me feel more as if I was on the other side of the world than twenty-four hours of flying. Sitting in that tin can in the air, extracted from a regular understanding of time while floating in a painful limbo where minutes tick past relentlessly, I wondered what on earth I was thinking getting on to the plane, and already started to dread the return journey. If it had not been for the agony of the long-haul flight, I could have imagined, upon landing, that I had not travelled anywhere at all. The sky was a little bluer. The sunlight bit into my skin thanks to the diminished ozone layer, but the shops were the same and downtown could have been any number of Western cities I had visited before. Yet I still felt far away. Opening my phone in the morning and scrolling through the news feed, I felt out of sync with the world. When night was day and day was night in a place that was pretty much out of reach of nukes and wars, global politics took on an abstract, conceptual feeling.

Street art and graffiti had a strong presence in the city. In stark contrast to my trip to Cairo, painted walls had been embraced rather than suppressed. The burners and 'pieces' of the inner city lanes and alleyways had a strong New York graffiti influence: the elaborate writing of their own moniker on the walls was prevalent.

This practice was understandable and aligned with the common motivation for graffiti writing being one of 'I am here, I exist'. Young Australians who were heavily influenced by American and European culture, but physically situated on the other side of the world, felt its influence while

being outside of it and having little influence on it. I enjoyed the bright colours and skill displayed on the streets downtown – it added life to the place, but wasn't quite what I was looking for. I was looking for work that was uniquely Australian, that wasn't just versions of the work I had seen everywhere else. That was when I turned a corner and my eyes met the work of Adnate.

The 23 metre- (75.5 ft) high downtown mural of an indigenous boy overlooked the Aboriginal site Birrarung Marr. The shining eyes acted as a reminder to those that pass along the streets below of the indigenous population and Australia's history. I would see Adnate's work across the city, and found myself equally moved by the Aboriginal child's face he had painted on the side of the Black Dot Gallery, in the suburb of Brunswick, that showcased the contemporary artwork of indigenous cultures.

Once in the suburbs there was a noticeable shift in the content of the street art and murals on the walls, hinting at a different motivation for painting and leaving a mark. Like the rings of a tree trunk, the work downtown felt young and centred around the quest for individual recognition, but out in the suburbs of Collingwood, Brunswick and Coburg, the locations of artist studios and a greater mix of cultures, I came across more pictorial and narrative-based urban art. Work that talked of 'others' and had an outward focus.

I ate lunch at the Moroccan Deli-cacy in Brunswick East. On the outside of the building, the deli owner had commissioned a mural by the artists Ms Saffaa and Molly Crabapple. Ms Saffaa, a Sydney-based artist who was brought up in Saudi Arabia, created the work as part of her 'I am my own guardian' campaign, along with New York artist Crabapple. The campaign and work sought to highlight the struggle that Saudi women faced as a result of the restrictive guardianship laws placed upon them – Saffaa herself falling victim to them when she was attempting to complete her degree in Sydney but was instructed that she was required to live with and be under the supervision of a male guardian if the Saudi authorities were going to continue sponsoring her visa. The work on the walls of the deli lasted less than one month before the faces of the women were defaced with black spray paint. The reasons for the women's faces being obscured was unknown, but the rising tide of Islamophobia in the Western political climate was one speculation and, in a way, as heartbreaking as it was, this added an additional layer of narrative to the work – work which spoke of the struggles of these women in the country in which they were born, who were also facing struggles and marginalization in the places that they moved to.

Another strong voice in the world of Melbourne street art came from Lush. It was hard to miss the gigantic mural of a pregnant Beyoncé surrounded by flowers. Calling himself a meme artist, Lush takes pop culture, memes, politics and Internet celebrities, and paints controversial work on walls around the world. Bypassing the isolation I had felt on my arrival in the Southern Hemisphere by harnessing the power of the Internet and social media, Lush taps into the mass-media zeitgeist.

With his 226,000 Instagram followers at the time of writing this, his technique of getting people's attention is definitely working – a contemporary way of 'getting up'. When your name is attached to your work on social media, perhaps this frees people up to produce different content in an effort to increase their audience – 'getting up' by providing controversial images that make the most of the transient nature of both the Internet and the act of painting on walls that would be shared rabidly. The greater the gut response, the faster the reaction, and therefore the more eyes that would see the work. Historically, street art and graffiti was so bound to place, and here was somebody recognizing that this did not have to be the case any more, and that the Internet had become its own space – which was not being targeted quite so aggressively by anyone else that I had discovered. This Beyoncé piece was also defaced, but in a way it didn't matter. It existed in its pure form on the Internet and, by the time it was defaced, the image it was taken from would also be old news.

A few days in to my explorations of the city, I met with the Melbourne-based artist and muralist Tom Civil in his Collingwood studio for a cup of tea. Tom told me about his background in political activism and his punk roots. From seeing where he was from and the passion he had for encouraging change in society, for highlighting what was wrong and not just letting the unacceptable become accepted, you would think that his street art would take on an aggressive or satirical language. Instead, it was fuelled by his desire to help make communities better. His murals were uplifting and positive additions to the walls of the suburbs. His themes of native Australian trees, rivers, rocks and bones, covered in joyful stick people, all worked together to bring a bit of the wilderness back into the concrete urban environment. It was work that was uniquely Australian, reminding those who saw it of how special their home was, how unique the wilderness was; that it didn't have to be another generic homogenized pastiche of a city. It had its own identity – a complex one, built upon some horrors, but also with the possibility of goodness and community, and a wilderness uniquely its own.

So whilst much of the work downtown was heavily saturated by the stylistic language and context imported from New York graffiti culture, there were still places where a unique voice could be heard. Voices such as Adnate, who spoke to the Australian people in numbers large enough to match the scale of his work, or of Civil, who spoke within communities. Yet it was the paintings of Lush that truly broke the restrictions of this place on the other side of the world, as the influence they had was felt less in Melbourne, where many were painted, than in the digital world of social media where they came alive.

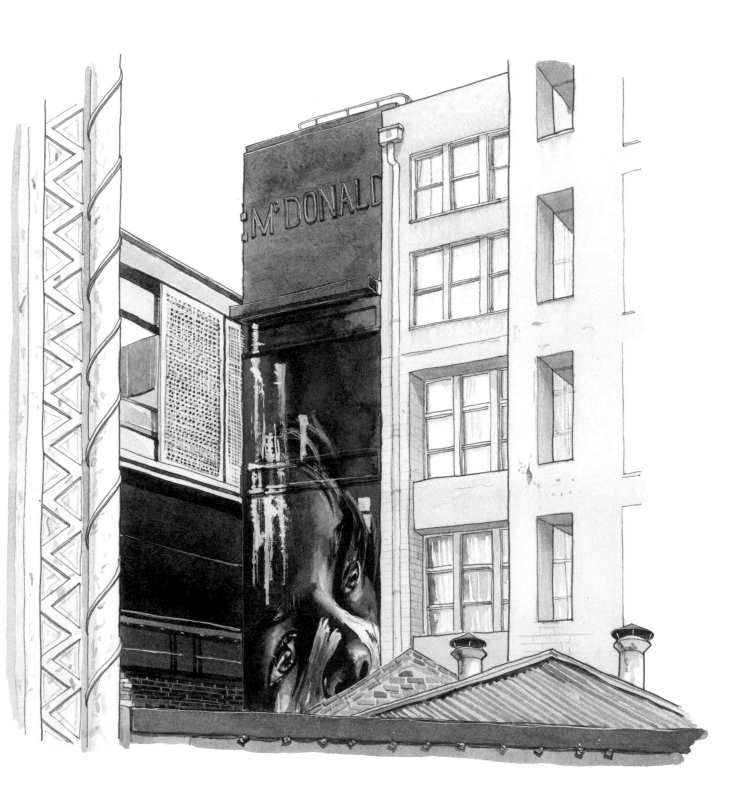

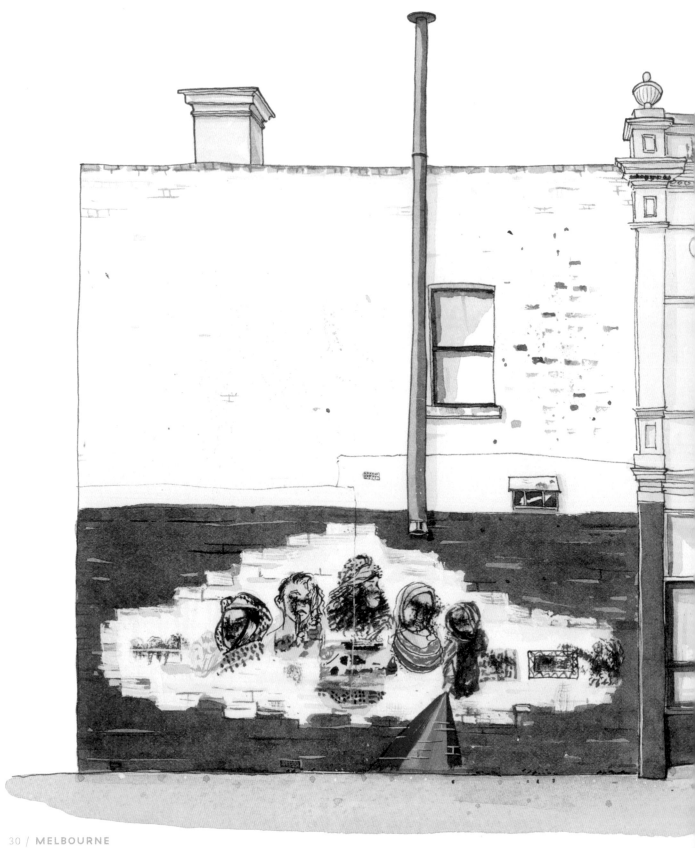

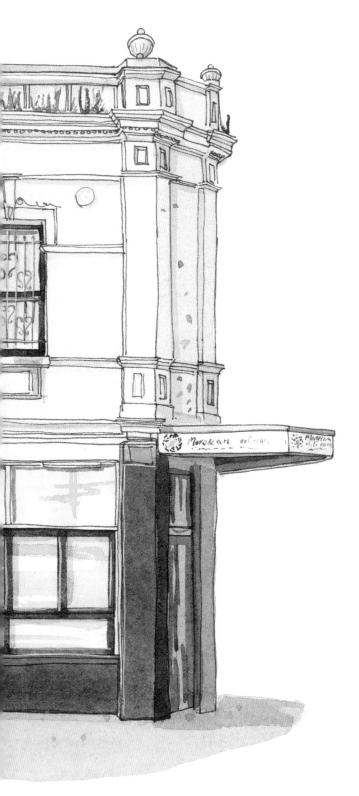

...work which spoke of the struggles of these women in the country in which they were born, who were also facing struggles and marginalization in the places that they moved to.

LEFT
Saudi Women by Ms Safaa
and Molly Crabapple.
Brunswick East, Melbourne.

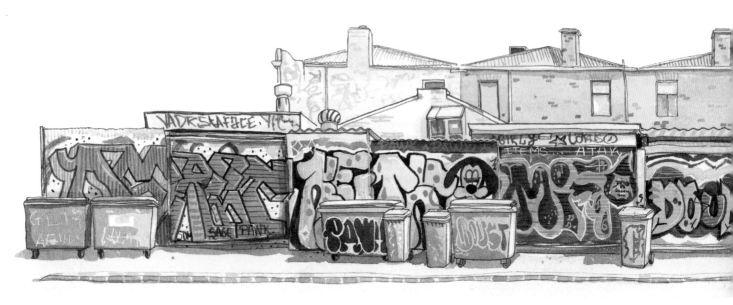

Young Australians who were heavily influenced by American and European culture, but physically situated on the other side of the world, felt its influence while being outside of it and having little influence on it.

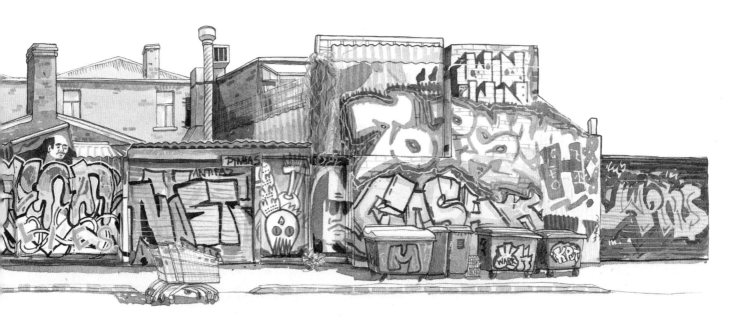

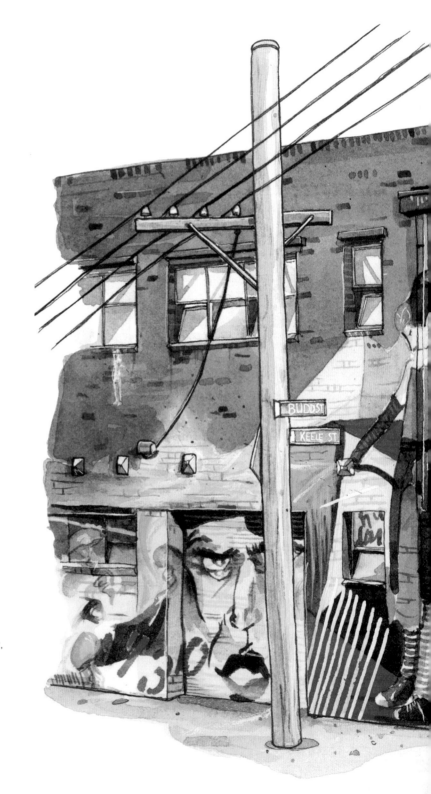

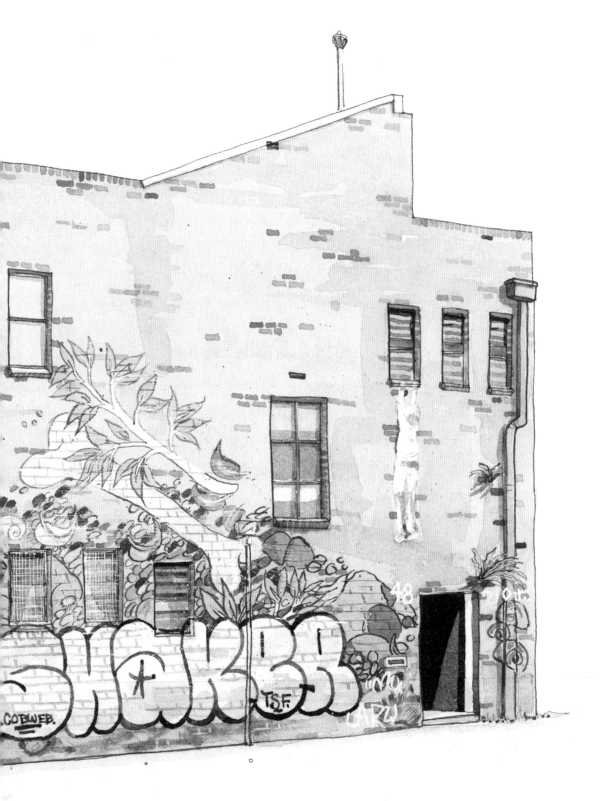

BELOW
Beyoncé by Lush. Collingwood,
Melbourne.

bateman 46 WEBB

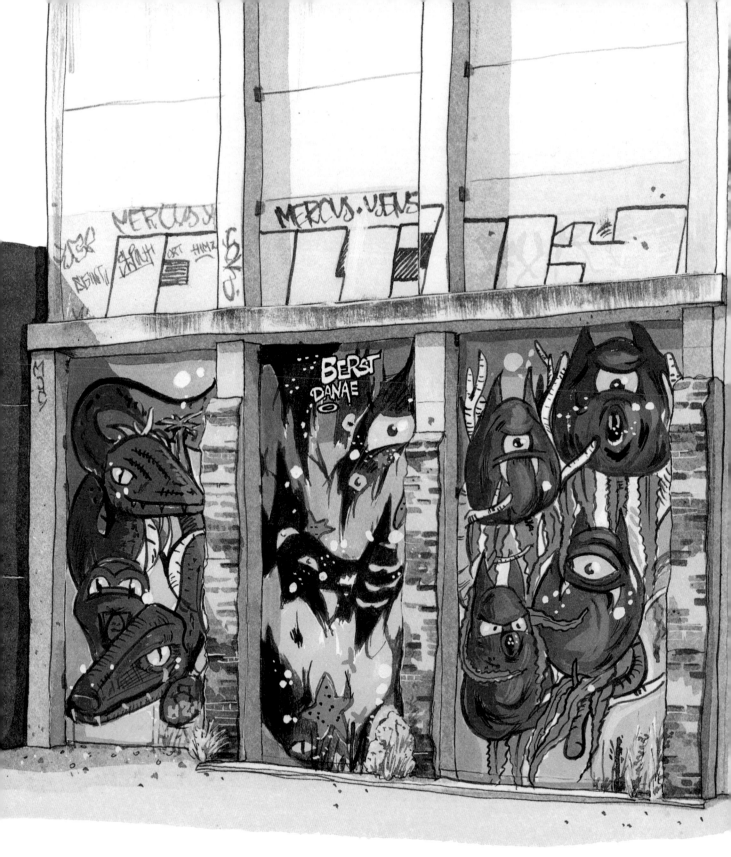

CHRISTCHURCH
NEW ZEALAND

Whilst visiting my family in Auckland, New Zealand, I took a plane down to Christchurch, a city dubbed the 'street art capital' of the Southern Hemisphere, in part thanks to its annual street art festival, SPECTRUM. Since the 2010–12 earthquakes that devastated much of the city, street art has been embraced and encouraged. Several people that I spoke to about the city said that it was young people who would keep the city alive, and who were most resilient to the years of aftershocks that had continued to shake the foundations of the whole Canterbury area. These millennials were priced out of the housing market across New Zealand, a whole generation of people forced to compromise and think creatively in order to establish any foundations for themselves.

It was just a short flight down to the South Island from Auckland. I was seated next to a man in his fifties who made regular visits to Christchurch on business. He had his own theory regarding when the earthquakes would hit the area, believing their timing related to spring tides – the period following each full moon and new moon when the tides are highest. He made every effort not to travel to the area during these dates, but this time found himself on a Christchurch-bound plane during a spring tide. He played with his cuffs nervously as we chatted about the mentality of the people who choose to continue living in a city where the ground writhed and groaned on a regular basis, or, where whole suburbs to the east of the city went from solid ground into flowing liquid thanks to liquefaction – a state where ground that was once stable was

turned into a thick mobile soup.

The conversation brought me back to a previous visit to the city, shortly after the 2011 earthquake, when I stayed at the house of friends in Sumner, a small suburb located at the base of Port Hills. The road outside the house was lined with shipping containers in a creative solution that would prevent further landslides and rock falls from crushing the small wooden houses. Back then, the rebuilding had yet to begin and many people were considering whether or not they wanted to stay. Between June 2010 and June 2012 the population had dropped by 2 per cent, and many more people wanted to leave but were trapped by lengthy insurance negotiations or stuck with homes deemed too dangerous to return to, even to collect possessions. On that visit, it had just been predicted that the city could expect another decade of aftershocks, enough to take its toll on anyone trying to plan how to rebuild their future.

If I felt distant from the concerns of global politics in Melbourne, this feeling was further increased in Christchurch. Global politics and terrorism were not even a blip on the radar – it was the ground beneath everyone's feet that offered up the biggest personal threat. Nobody can win a battle against the earth, and so those who remained in the city out of choice instead of forced by circumstance seemed pretty chilled out.

Before the devastation, there was very little street art or graffiti in Christchurch, New Zealand's oldest established city; the historic architecture, much of which was built in the late nineteenth century during the gold rush, was to be preserved

and maintained – a living museum and snapshot into the narrative of such a newly colonized country. Tourists would come from around the world to gaze at the Christchurch Cathedral or the Gothic architecture of The Press Building. Spray paint and markers were unacceptable on the dark basalt blocks and the cream stone facings of the century-old structures. The 2017 version of the city had very little of this history still standing. So much care to preserve that identity, and it changed almost overnight.

Whereas in Cairo the purpose of much of the urban art was that of a reminder of the lives lost in the revolution, in Christchurch it performed the role of raising morale and providing a distraction from the giant building site the place had now become. Walking around downtown, the constant noise and agitation from the construction work felt oppressive and stressful. Seventy per cent of the buildings in the Central Business District had either been, or were scheduled to be, pulled down and replaced, which would leave a huge impact on the city. The footprints of demolished buildings were almost all turned into temporary car parks. A young city was springing up from the ashes of New Zealand's oldest, and it carried with it a confusing identity. In any situation of great change or natural disaster there would be multiple responses from the community: those who saw it as an opportunity, those who wanted to take advantage, those who wanted to make the best of things, and those who wanted it to go back to the way it was. It was a fine balancing act for those in charge of rebuilding, attempting to keep the old aspects, whilst needing money from big business to fund construction.

Regardless, if Christchurch wanted to survive in any form – and some people questioned whether it should, given the long-term prediction of at least another decade of earthquakes – it would need to maintain a population and stem the tide of people relocating to other places. It would have to attract a whole new set of tourists and the money they would bring into the area.

The introduction of urban art to the increasing number of derelict sidewalls of the city made perfect sense. Providing a colourful distraction to the grey rubble, they were messages of hope, and appealed to a younger generation who would accept the short-term compromises for a stake in the city, bringing with them tech companies and start-ups. 'We Got the Sunshine' by Olivia Laila and Holly Rocck fitted this role of brightening up the city perfectly. Other work, such as the mural on Gloucester Street by Berst, brought in elements of Maori mythology to further enrich the environment. From as early after the earthquakes as 2013, street art and murals were recognized as having the power to help transform the city. A group named Ministry of Awesome gave themselves the task of revitalizing it through the arts. The group said of their work in the post-quake city: 'At a time when no one was looking, when people had ideas and room to play, we gathered together to activate our networks, break down barriers, cut through the red tape, and enable people to contribute to our city'. They teamed up with street art enthusiast George Shaw to explore the power that murals and urban art could have on the environment. In 2014, the work was added to with the first Rise Street Art Festival. Spectrum Street Art Festival made its way there in 2015 and

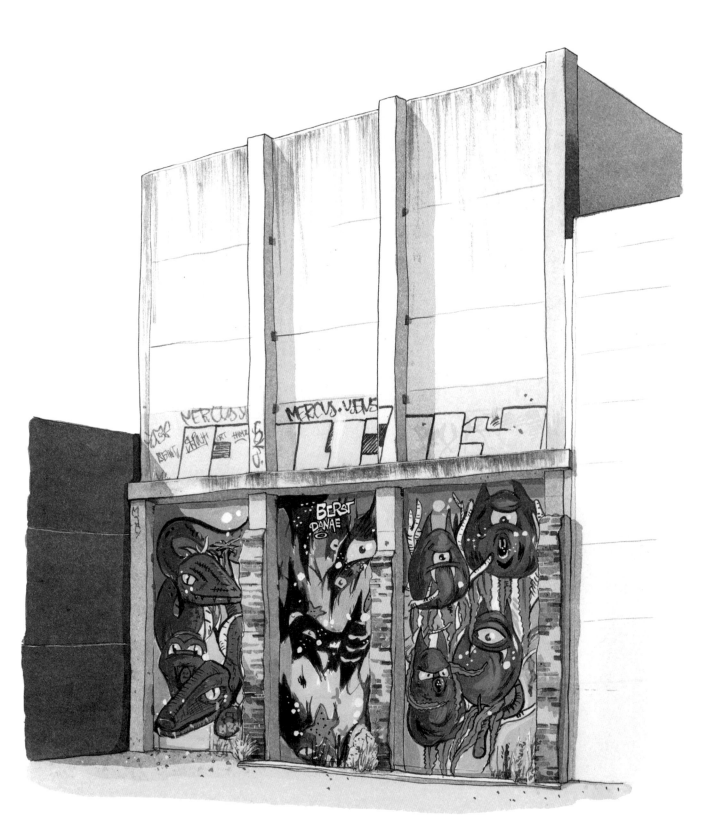

2016. By my visit in 2017, there were in excess of fifty murals around the city. The transient nature of urban art synchronized perfectly with the ever changing and evolving demolition and rebuilding that was happening. It also acted as a magnet for a new form of tourism and made Christchurch a destination again.

As I navigated the city, I noticed how everything being a building site blurred the boundaries of private property. Cones and wire fences were much easier to cross and explore behind than locked doors and inhabited spaces if you were perpetually curious. I climbed fences to get better views of murals, stood on top of shipping containers and crossed train tracks, nipped behind bollards to get a better look at the ornate stonework of buildings waiting to be torn down. As well as commissioned murals, there was a sprinkling of graffiti, much of which seemed to reside inside buildings only made visible when the insides became the outsides halfway through demolition, like the one on Tuam Street.

Unsurprisingly, graffiti as extreme sport was also visible on the few remaining high-rise buildings. After all, if the population is expected to thrive under the stress of imminent natural disaster, it makes sense that a percentage of those would also relish the adrenaline of scaling these abandoned buildings. I photographed reference of the Rydges hotel car park that featured a huge commissioned mural by the Christchurch artist Jacob Yikes. Directly behind it, the tag 'TOGO' could be seen in large painted letters on the top edge of the hotel building, painted from up on the roof whilst the building was empty. I thought about leaning over the edge of the roof far enough to paint the letters with rollers, in a city that regularly shakes and moves, and I gained a brand-new respect for the writers that dare to reach such spots.

Graffiti also found itself on the sides of shipping containers that were placed in front of unstable facades to prevent them tumbling onto pedestrians in the event of another aftershock. It was whilst I was standing on top of one of these shipping containers taking reference photographs of an elaborate wall, that a small earthquake hit. I was too busy scrambling around to notice, but others did and it became a source of conversation in places I visited later that day. Perhaps my own predilection for a little danger and excitement, for exploring places that were once inhabited, made me the perfect candidate for a life in this new Christchurch. I thought back to my neighbour on the flight in and smiled at the difference in our responses, understanding now why attracting a younger population was so important for the Christchurch that would rise up from the ashes and rubble.

I thought about leaning over the edge of the roof far enough to paint the letters with rollers, in a city that regularly shakes and moves, and I gained a brand-new respect for the writers that dare to reach such spots.

RIGHT
Tuam Street deconstruction, Christchurch.

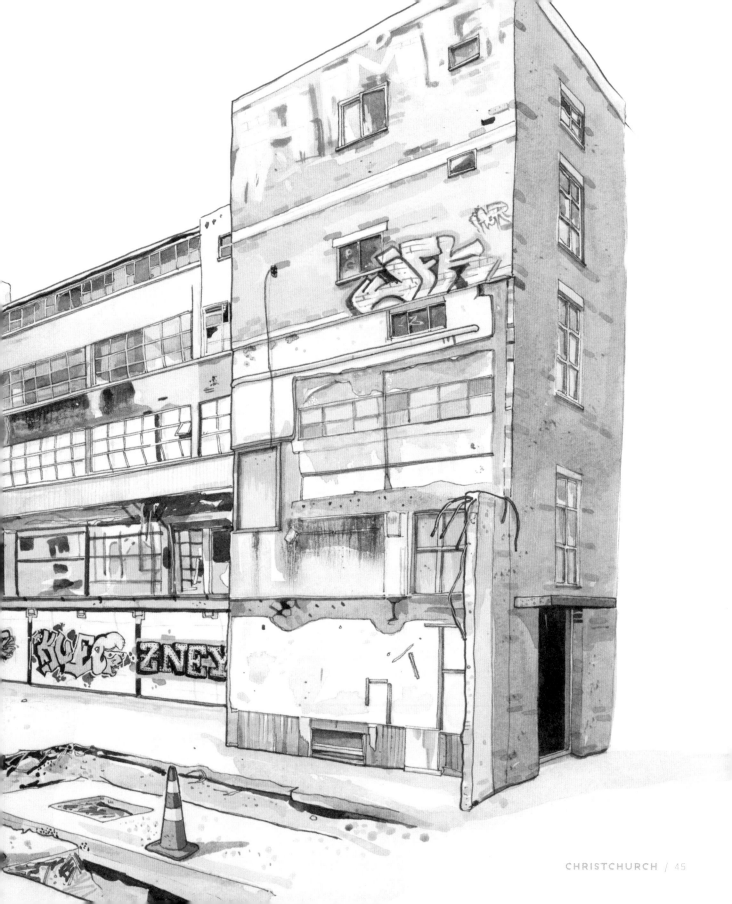

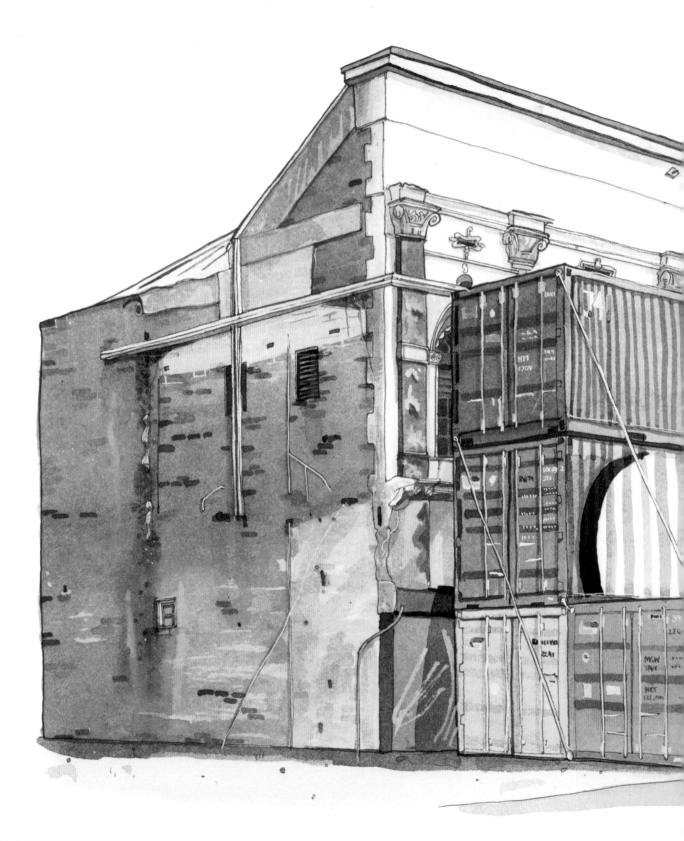

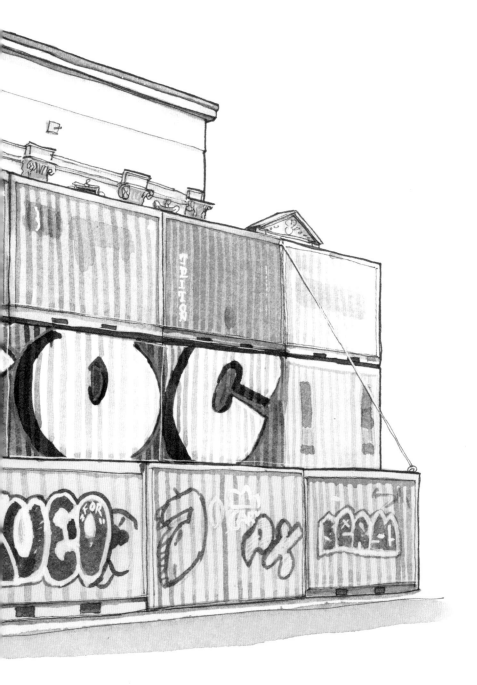

RIGHT
Shipping container walls,
Christchurch. Featuring FOC,
KUEO.

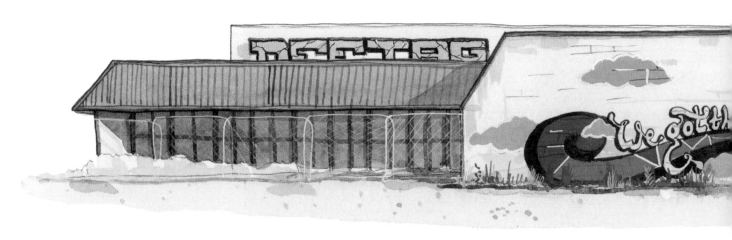

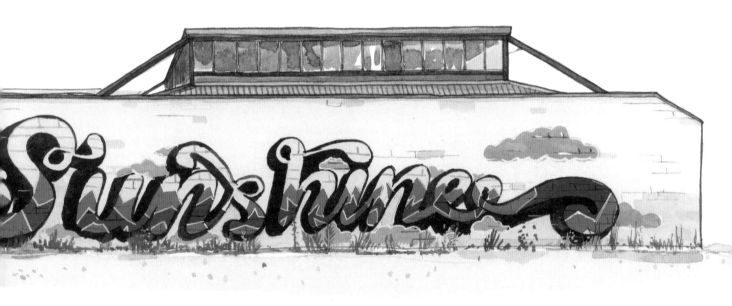

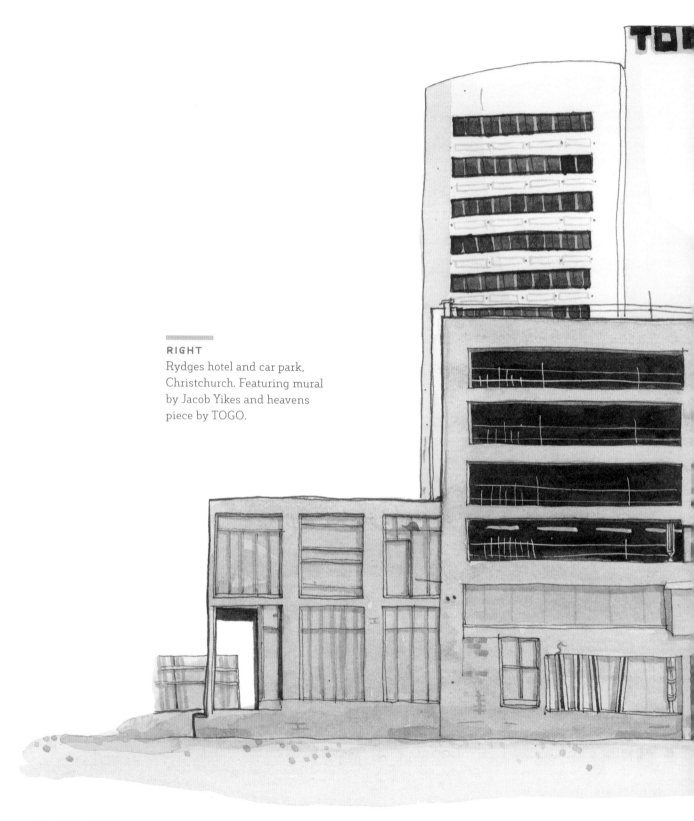

RIGHT
Rydges hotel and car park,
Christchurch. Featuring mural
by Jacob Yikes and heavens
piece by TOGO.

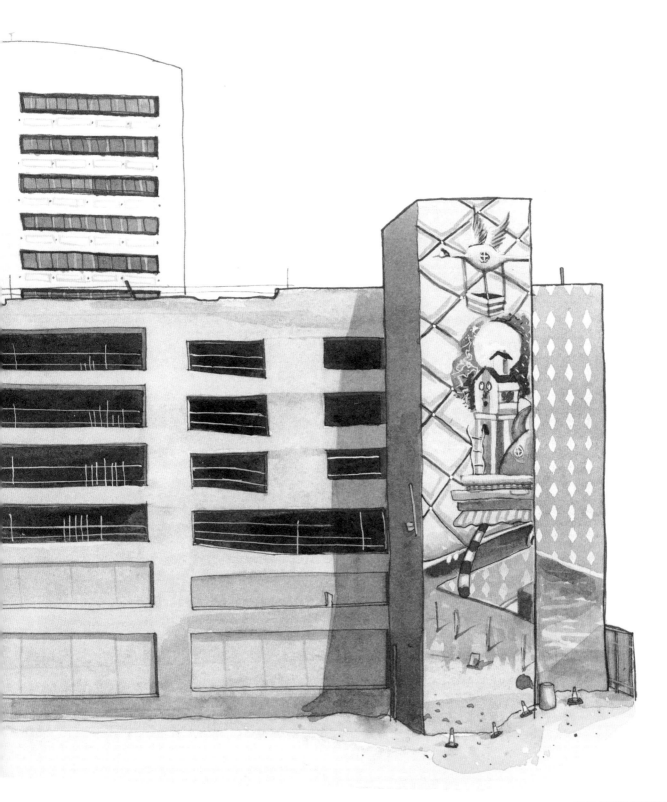

NEW YORK
USA

New York! I'd arrived with a plan for New York. One of the birthplaces of modern graffiti, I'd made it my mission to hunt down some of the oldest pieces that still existed in the city today. This was the place where writing your own name in public turned from a strange expression and act of rebellion by a small group of friends, into a worldwide epidemic that I had been crossing oceans in search of.

My plan ended up not quite working out the way I had hoped. I had a list of locations and spent a day turning up to spots all across Manhattan to find that the work no longer existed. The location of one piece was now just a buffed cream wall. Another had a large advertising video screen screwed in over the top of it. The city was changing so rapidly that only two of the works on my list still existed. One of these was Keith Haring's 'Crack is Wack' piece. It was 32 degrees Celsius (89.6°F) in Manhattan on the day I took the subway over to Harlem to find the work. I skated along the bustling Harlem high street before pushing along the back streets for a while. I reached the handball court next to Harlem River Drive, the location from my research, to find. . . nothing. Well, yet more building work, fences, diggers and hi-vis-vested workmen. I hunted around the areas I could get to, then nipped behind the fences to have a better look. I cross-referenced old images of the piece, looking for clues in the landscape of the exact location, but the rebuilding of that part of the highway meant that nothing quite matched up.

After a while of fruitless searching there was one answer right under my nose. A large tarpaulin-covered structure may just be protecting the work from getting damaged by the construction. I found a gardener in the park beside the handball court and asked him. He confirmed it. Yes, the work was beneath the thick sheets of blue plastic.

Painted by Haring in 1986 without permission, the location next to such a busy highway and bold message would help propel Haring into becoming one of the most iconic street artists of the 1980s. He was arrested as soon as he finished painting the wall, yet the positive publicity that the mural received, at the time crack was a growing national problem, resonated with the media, and this publicity ultimately spared him from going to jail. The original painting was then vandalized a short time later, but this same positive publicity for the piece led to the Parks Department asking Haring to repaint it. The repainted version was not identical to the first but the message was still the same, and it is this version that was sitting under cover with the protection of the city three decades after his arrest. I had seen, time and time again, instances of people who pushed at the boundaries in search of artistic expression who would then be held up by the very hands that once pushed them down. Their work would be used to raise property prices and sold to art dealers.

Back from my trip out to Harlem, I went on the hunt for one final historic piece of graffiti by the writers REVS and COST. Prolific and creative from the 1980s onwards, they too pushed the boundaries of what could be considered graffiti in the pursuit of 'getting up'. 'Getting up' is the aim of making a name

for yourself as a graffiti writer, either by spreading it through volume, scale or remarkable location. REVS and COST were some of the first to utilize paint rollers instead of spray cans so that their work could be completed at a much larger scale across Manhattan; the technique used by these artists was rejected by many at the time for not being 'real' graffiti, but would become adopted across the globe years later, a precursor of other methods for producing large-scale graffiti, such as the fire extinguisher work by the likes of Katsu.

I walked the High Line looking for the piece I had heard about. After all of my disappointing searches, and the volume of high-rise building that butted right up to the above-street walkway, I was sceptical as to whether I would find what I was looking for. I stopped by a large group of tourists looking out and taking photographs of some murals on the walls opposite and hunted the brick buildings for the huge roller letters I was looking for. After a few minutes of hunting I turned around and glanced at the wall behind me – the wall that saw a thousand backs. There it was. The large paint letters were faded and flaked and unremarkable, unless you knew the story of where they were from.

In 2011, during the construction of the High Line, it was feared that the graffiti would be removed altogether. One day, workers painted over the letters with some kind of removing substance; the next day, the letters still remained but as a shadow of themselves. A ghost on the wall, faded to almost the same degree as the original painted advertising on the sides of the warehouse declaring the warehouse owners. The similarities in the text

also reflected the similarities in the human urge to have one's name known. To write it large for all to see, as if seeing it is tied into your existence.

A few days later, I travelled to an old industrial area of Brooklyn called Bushwick, one of the few parts that still contained warehouses. It was now famous for the street art and murals all over the walls that were repainted every year during a large community event with music, food and live painting. Thousands of people flocked to the area, cramming the streets. The Bushwick Collective was the group name for the work that was everywhere. I had seen many of the artists' work in other cities around the world – artists moving from place to place, leaving their mark.

There are very few places in New York where street art is allowed, and so seeing such a large concentration all in one place made the area unique. It wasn't long ago that there was no billboard advertising here – there weren't enough passers-by to warrant it. Yet, as the popularity of street art rose, and the work of international muralists continued to fill the walls and draw people in, other signs of gentrification popped up – high-end coffee shops, cool bars, restaurants and advertising. There was a growing trend for large-scale, hand-painted adverts, made in such a way as to integrate them with the street art, borrowing from its visual language and incorporating the kudos of craftsmanship. My thoughts went back to the large warehouse in Manhattan with the name of the warehouse owner painted across the side. Was this just a modern version of that?

When walking around looking at the street art and murals, a graffiti writer friend pointed out that the content of the work on the walls was also heavily curated by the building owners to ensure that nothing controversial was painted. Artwashing is the term given to the gentrification acceleration technique by property owners or developers wanting to raise the value of their area by commissioning art projects and murals on their buildings, attracting a different demographic with more money to a previously overlooked neighbourhood. The rough brick walls then become shabby chic, industrial warehouses become loft apartments and landlords become rich. Whether intentional or not, the large collection of work in Bushwick has had some role in the rise in rent and business rates, driving long-term residents out from the neighbourhoods they grew up in. This idea of the gradually changing sociodemographic population of an area drew me to one particular piece of work in the centre of a construction site in the heart of Bushwick. Hanging on a large steel I-beam was the word 'Home', seemingly cut out of thick steel. I could not help but feel that, when the construction was over and the word no longer hung on the edge of the I-beam for all to see, this place would not be home to many who had once called it so.

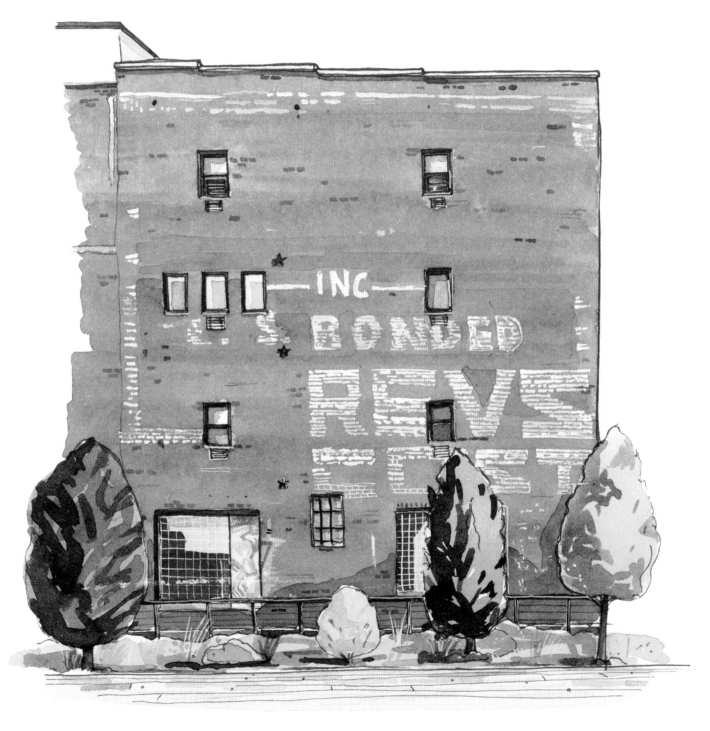

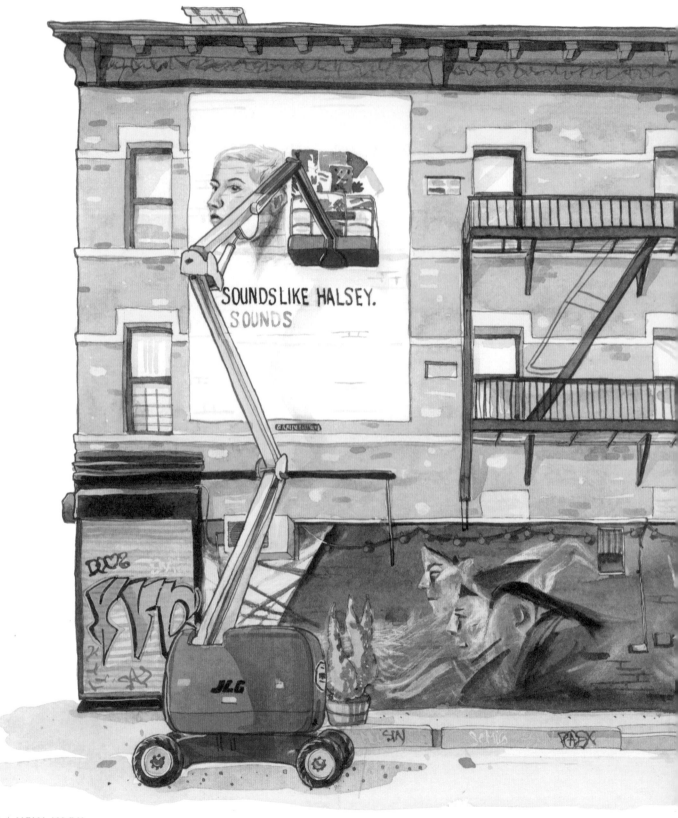

The rough brick walls then become shabby chic, industrial warehouses become loft apartments and landlords become rich.

Handpainted billboard. Brooklyn, New York.

This was the place where writing your own name in public turned from a strange expression and act of rebellion by a small group of friends, into a worldwide epidemic that I had been crossing oceans in search of.

RIGHT
Near the Holland Tunnel, New Jersey. Featuring INDECLINE, buff monster, COST, Nychos, MSK.

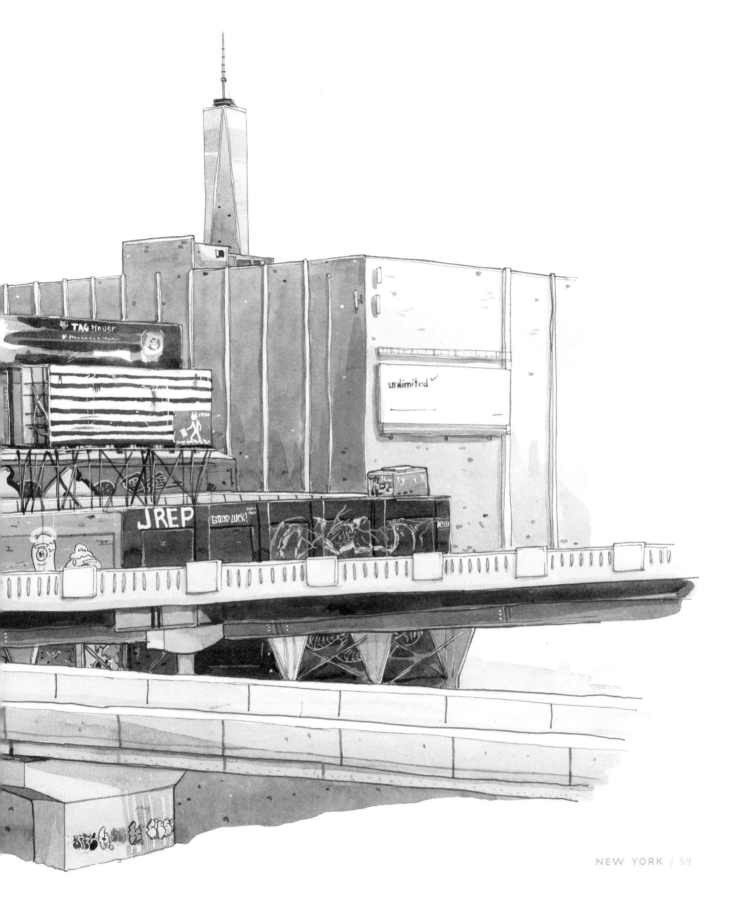

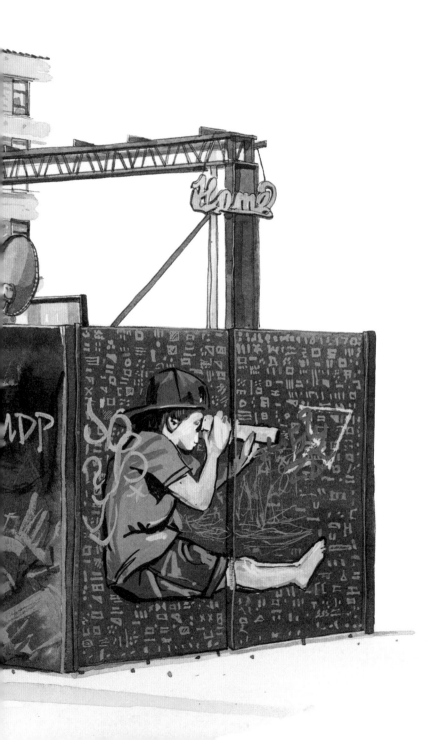

'Home', Brooklyn, New York.
Featuring Joeiurato x Logan
Hicks and Killz Montana.

LOS ANGELES
USA

Los Angeles: a city filled with people who shared the dream of seeing their name in lights. Those who desired to be known and to stand out from the crowd were often moved by an urge so similar to what motivated many graffiti writers that the parallels were uncanny. Home to Hollywood and Sunset Boulevard and the Walk of Fame and to those who had made it, in their huge Beverly Hills mansions. Home also to the many more who were sacrificing everything in the hope of one day receiving the acclaim that they dreamed of.

Whilst New York is often given credit for the birthplace of graffiti and tagging (in the form that we know it today), it was Los Angeles where the different environmental factors played into innovating new ways of 'getting up'. A sprawling city of freeways, the painting of graffiti on freeway signs, known as 'heavens', gained more attention and was a daring alternative to train bombing, the East Coast favourite for 'getting up'. The car rather than subway culture played a large role in this difference. If the goal of successful graffiti was to get as many eyes to notice it as possible, this was a clever solution. Another element feeding into the Los Angeles style came from the Chicano gang graffiti of the Sixties and Seventies that had a carefully meticulous hand style. This played some part in writers of the Eighties and Nineties taking time over their writing, pulling in elements of calligraphy and handwriting, often elegant and comprised of a single line.

I cycled around the downtown arts district with my guide, a local graffiti writer called Carlos.

Bikes were the best way to cover the large areas between the industrial buildings and to cross under the freeways whilst still allowing us to stop every hundred metres so that I could shoot reference photographs and hear stories. We passed several different people working on murals under a bridge, and Carlos stopped and chatted to them all. Cache K4P was one of them, part way through painting a new wall. I saw a slice of the community aspect of a world so often talked about in terms of being individualistic or even egocentric. We paused at the work of some of the more famous street artists and I was surprised to see the lower half covered in tags and throw-ups.

A rebellion was happening: a conflict between the street artists and graffiti writers in downtown Los Angeles. There was a rise in awareness of how turning industrial areas into open-air art galleries and tourist attractions had the effect of increased rent, and priced nearby long-term residents out of their communities. As a general trend, a lot of graffiti writers were local to the area where their work could be seen, whereas it was unusual for street artists to be located within the communities where their work was painted. I heard about neighbouring Boyle Heights, an affordable and largely Latino and Hispanic community that was earmarked for redevelopment. The backlash from anti-gentrification groups took the form of vandalism of the new businesses opening up. Controversial and desperate, but perhaps these same motivations were being seen written on the walls in the arts district. Local residents were pushing

back the tide of development in any way they could; showing their displeasure at what felt like the slow invasion of their communities. My guide told me of a piece by the street artist ROA that had been tagged over, and ROA had returned to repaint it, then the repainted image had been heavily tagged over again. Other street art pieces had been tagged, but in an effort to clean up the tagging, more prominent graffiti writers then moved in and covered the tags with large skilled 'pieces'. The respect that they carried within the community left their pieces mostly unspoiled. There was a complex conversation happening on the walls of the buildings in this area between the different communities of street artists and graffiti writers. The conversation was happening at different times, perhaps between people who would never actually meet, but the paint-covered brick and metal structures contained a palimpsest of dialogue.

Just a few days earlier, I had been sitting outside a coffee shop in Venice Beach talking to a stranger. He told me about how he moved to Venice Beach a decade ago to make a new life for himself, but the rising rents had driven him from one neighbourhood to the next, pushing him further and further away from where he worked chasing affordable rent, but he had reached the point where he was going to have to move to another city altogether. The perpetual relocating was making it harder for him to establish proper relationships with the people around him as he slowly got pushed from one place to the next.

Having seen the hollowing out of communities

and areas in cities around the world due to gentrification, I had developed a new interest in the groups that were using whatever means at their disposal to hold their ground. Those that could see the trend and patterns of countless other neighbourhoods as rents increased to unaffordable levels, forcing small businesses to pack up, and residents to move to different areas.

Back in Venice Beach, right next to the world-famous Skatepark, were the Venice Art Walls. A free and legal place where anyone could paint, spray or paste, these walls had been in existence for more than fifty-five years. Originally built as the Venice Pavilion in 1961, much of the pavilion was torn down in 1999, but sections of it plus the chimneys were kept as living memorials to the graffiti and murals that had covered them for decades. The walls were now run by the Setting The Pace (STP) Foundation, a community arts organization set up in 1987 to utilize the power of art within the community for positive change – a recognition of the power of allowing people a place to express themselves, and how this could become a force for good in the world.

Looking for more ways in which graffiti had united people, I headed back to the Santa Fe area of downtown LA. The boxy shape and large size of the concrete cube architecture lent itself perfectly to huge back-to-back murals and collaborations. One of these buildings, a large plumbing warehouse in southeast downtown, would become one of the largest collaborations in the whole of Los Angeles. UTI, a graffiti crew that consisted of over 200

members and celebrated their thirtieth anniversary in 2016, pulled together to produce the work that wrapped around two sides of the huge warehouse. Thirty of the crew's members worked tirelessly to produce the piece in time for their anniversary celebrations. Completely covered, the quality of work was exceptional, yet it was a combination of many different styles, harmoniously sewn together, allowing each individual to shine without their work becoming homogenized or replicating each other. The crew also invited Los Angeles-based street artists to contribute: El Mac, with his portrait work made from sprayed concentric circles, the intricate calligraphic work of Retna, and the graphic lines of Kofie. After seeing so much conflict playing out on the walls in the arts district, it was the perfect contrast to see how the art form could be used to unite people, to allow them to express themselves in their own unique way but be tied together to create something as a group. Like a choir singing a song, each contributor brought a different tone, making the song fuller and richer than a single voice could ever achieve.

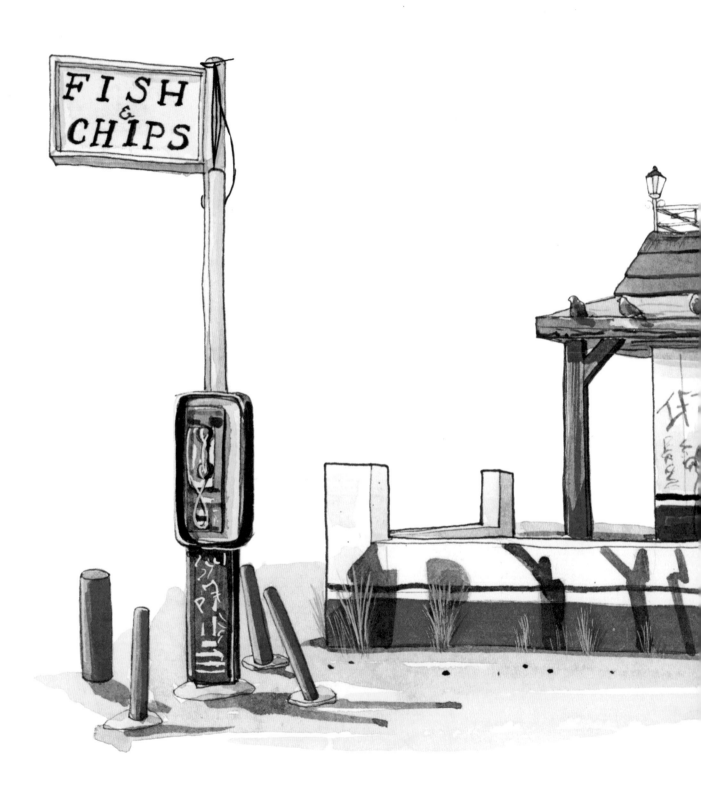

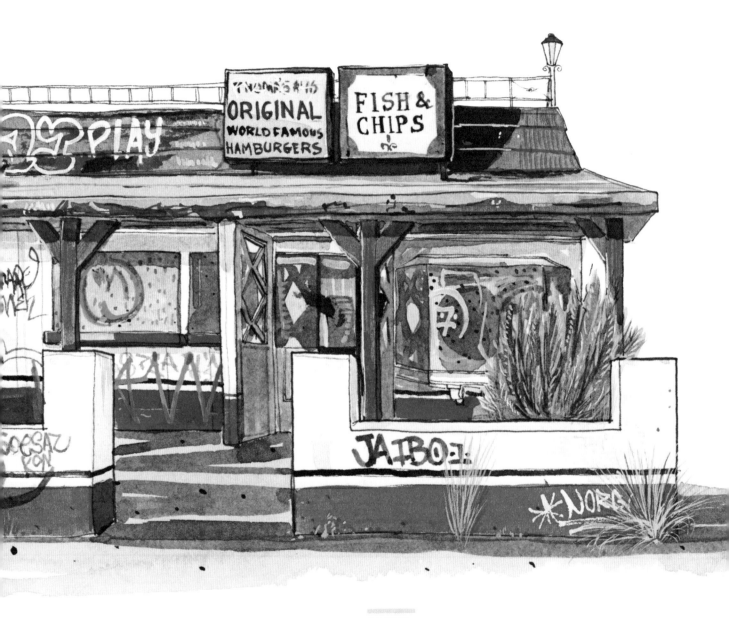

ABOVE
'Fish and Chips', Venice, Los Angeles.

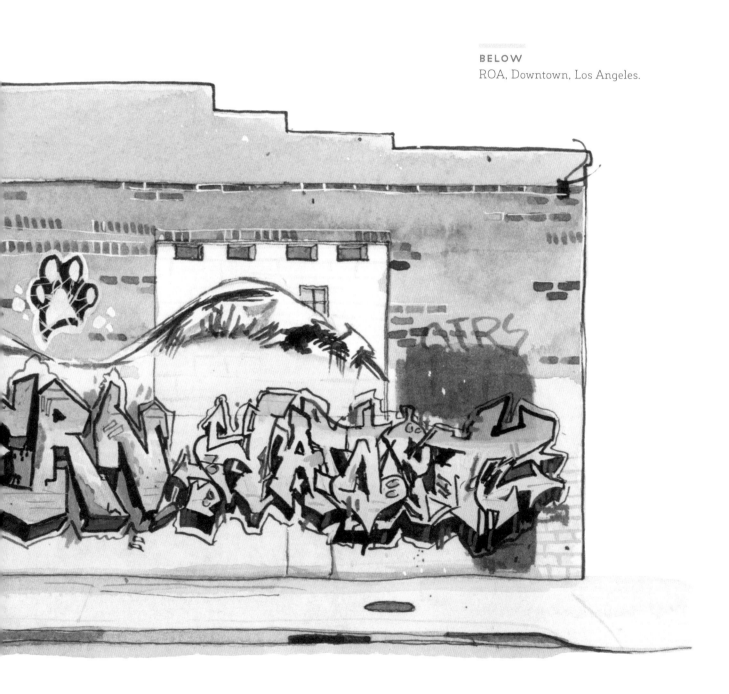

UTI thirtieth birthday
collaboration, Downtown, Los
Angeles. Featuring
El Mac, Retna and Kofie.

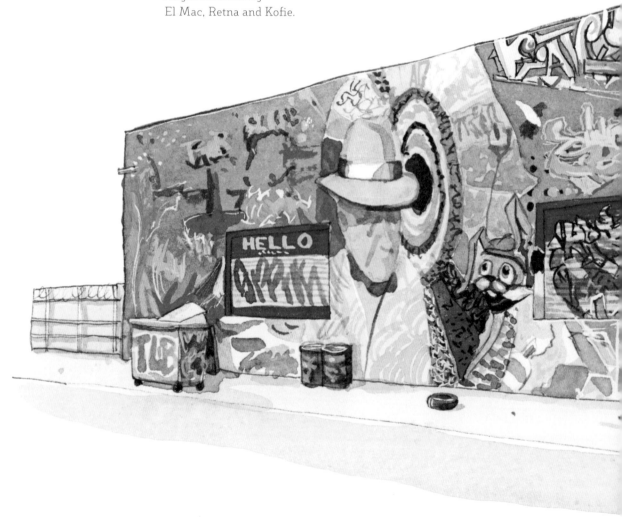

ABOVE
Back Alley, Downtown, Los
Angeles.

I saw a slice of the community
aspect of a world so often
talked about in terms of being
individualistic or even egocentric.

DETROIT
USA

I'd heard rumours of Detroit being a dangerous city to walk around. It was only when I turned up at my friend and host's house and she showed me the location of the baseball bats next to each entry point of her incredible mansion of a house, then handed me a pocket knife to carry with me wherever I went, that I realized the rumours were probably true. She gave me strict instructions not to walk around outside on my own after dark, and to text her the locations that I was going to explore each day so that she could check them for safety.

Detroit would quickly become my favourite city in the USA. The lawlessness and shorthanded policing had the side effect of allowing creativity to thrive. As I spoke to people who had lived there their whole lives, I would hear wild tales of adventures. The Packard Plant was the site of many childhood escapades: motorbike races through the building, room after room of graffiti writers practising their skills on the walls, frozen pools of water on the roof becoming open-air hockey rinks in the winter, skateboarders building DIY spots where warehouses once stood. It was a dangerous and exciting playground for people to run free.

The history of Detroit is one of riches to rags, of racial tension and endemic corruption. The concentration of automotive companies in the city led to it becoming one of America's wealthiest in 1960, but a gradual decline resulted in it filing for bankruptcy in 2013. The 1967 race riots resulted in the White Flight, where thousands of white Detroiters fled the city centre and moved out to the suburbs. It became a place that was overlooked or ignored by the homogenized brands and shops that were the norm in every other city in the USA (and many other parts of the Western world). The lack of supermarkets made the Eastern Market the place to buy groceries for the week. Small, independent shops that had been in place for decades still kept their doors open. It truly had a flavour all of its own, and I realized just how much I had missed that on my visits to other Western cities, and perhaps why I was drawn to the alienness of cities such as Bethlehem and Cairo.

Just as with every place, however, things were changing. There was a new mayor who seemed to be taking lessons from New York's implementation of the Broken Windows Theory in the 1980s and early 1990s: the idea that crimes resulting in disorder, such as graffiti, should be punished harshly.

A graffiti writer friend drove me around to the different suburbs and told me about growing up in Detroit, being able to spray up 11-colour burners in broad daylight on busy roads without anyone batting an eyelid. He showed me some of his remaining throw-ups and tags near a half-collapsed warehouse that had some DIY concrete skate ramps constructed inside. He took me to the Packard Plant, one of the largest abandoned warehouses in the world, which would have once been covered in brightly coloured paint, but now sat buffed to brick red. A security car turned up within minutes of us stopping to look to make sure we knew that we were not allowed to set foot on the site. My friend said he'd capped his spray cans because the risks were too great under the current mayor. Two graffiti

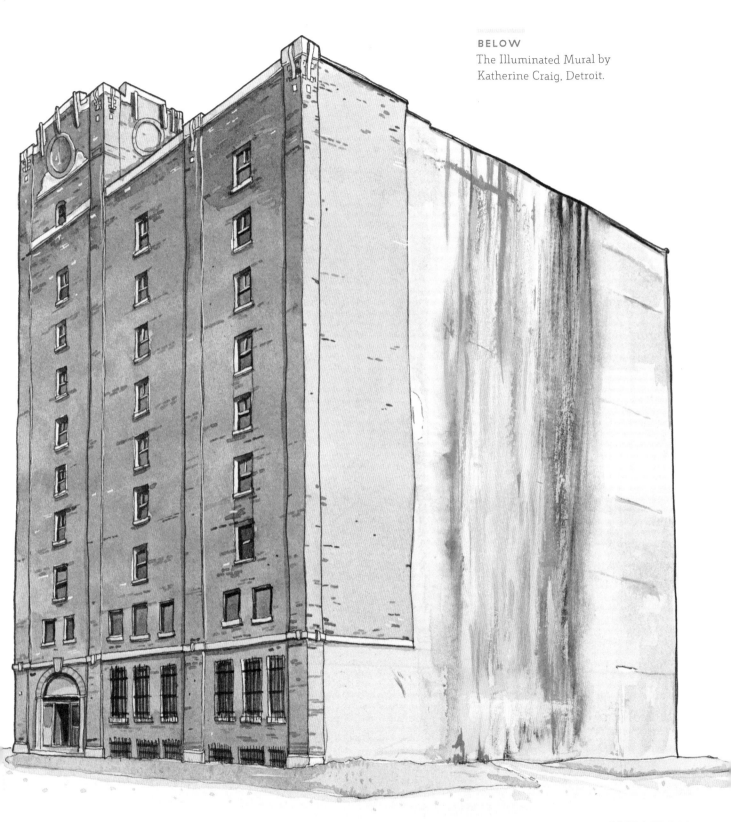

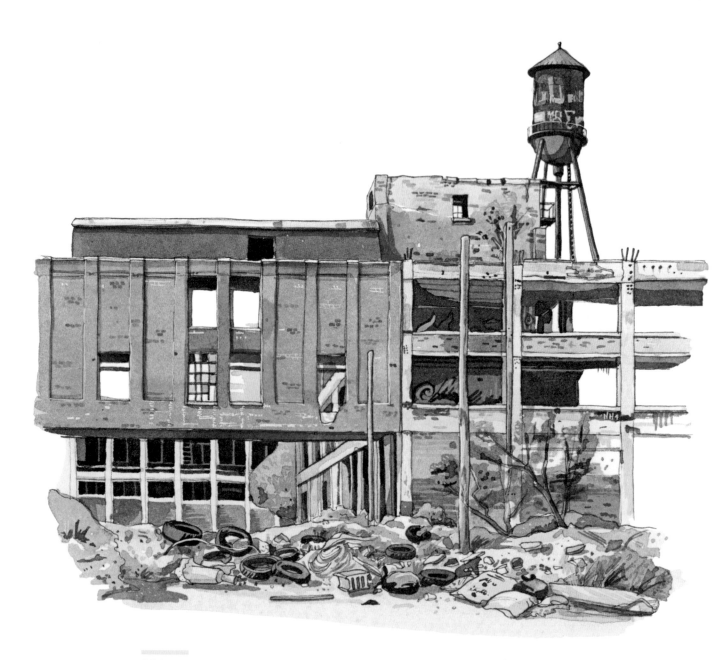

ABOVE
Packard Automotive Plant,
Detroit.

writers had been arrested for spraying a water tower and were facing the possibility of long prison sentences, yet what annoyed him the most was the contradiction in the city. The co-opting of graffiti culture as a signifier of cool in the downtown areas, yet the very same act could land people in prison.

The Z Garage downtown was one such example. The multi-level structure featured the work of a different international muralist on every floor, flown in to adorn it with their work, and it charged a premium for the privilege of parking in such a place. As I spent a couple of hours recording the work on every surface, what came to mind was the lack of any real narrative or message in any of the works. It was exceptionally executed by talented artists whose work I had seen in other cities around the world, but here it was floor after floor of abstract colour and pattern. Street artist Shepard Fairey was commissioned to produce work for the Z Garage and multi-floor piece on a nearby building, and whilst in Detroit he also sprayed unauthorized work elsewhere in the city. In response, the City of Detroit lodged criminal charges against him, thus bringing even more attention to the contradictory way in which the city was trying to own the culture, profiting from the parts that they liked and criminalizing everybody else. The tide was turning for the city.

However, one such work that seemed to flip the detrimental effects of 'artwashing' on its head was 'The Illuminated Mural' by Katherine Craig. The artist took the property developers to court when they wanted to convert the nine-storey building on which her work was produced, arguing that turning the building into condos would destroy or mutilate the artistic work. The case was built around a combination of a 1990s copyright law and the fact that a condition of receiving a grant to produce the work in the first place required a guarantee of longevity for the work's existence. When undertaking the piece she had signed a contract agreeing that the work would last for at least a decade from the date it was produced in 2012. She won the legal battle. The unique combination of circumstances and creative thinking shifted power away from the building owner and into the hands of the artist.

Detroit had suffered greatly with the collapse of its automotive trade. However, through that hardship, seeds of creativity and freedom had blossomed. It still maintained its own personality where most other cities I had visited in America, Australia and Europe had succumbed to an amount of homogenization. So, whilst things were in the process of changing in Detroit, there was hope that the resilience and creative thinking of the residents would help to push back a little against the more culturally damaging changes.

Detroit had suffered greatly with the collapse of its automotive trade. However, through that hardship, seeds of creativity and freedom had blossomed. It still maintained its own personality where most other cities I had visited in America, Australia and Europe had succumbed to an amount of homogenization.

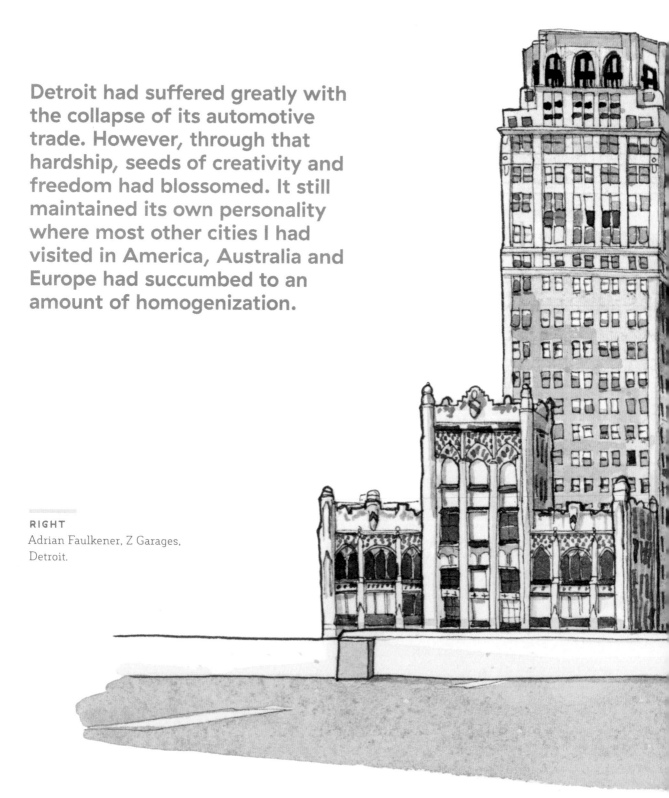

RIGHT
Adrian Faulkener, Z Garages,
Detroit.

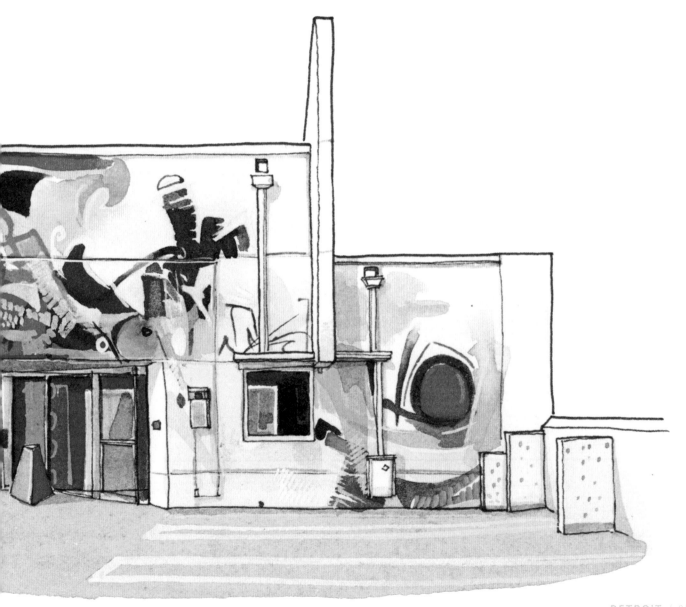

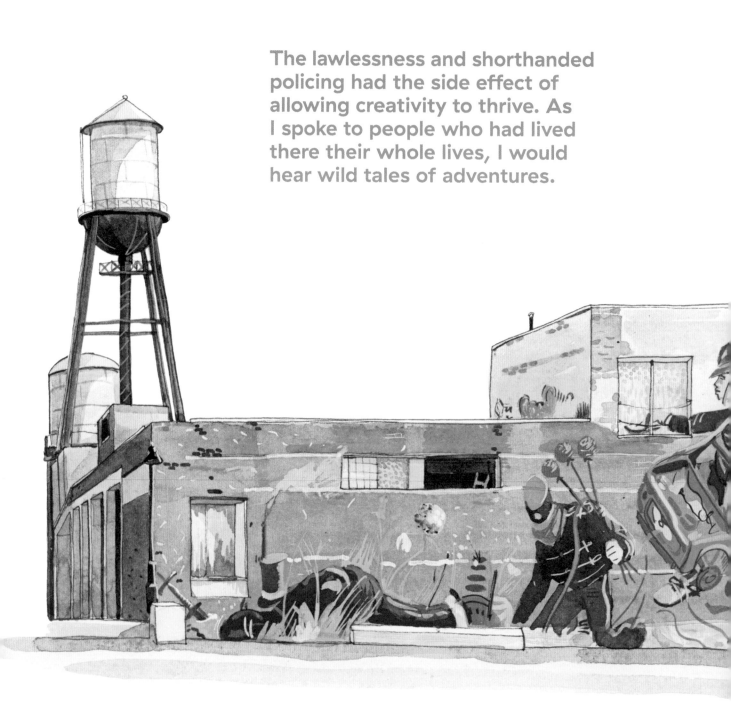

The lawlessness and shorthanded policing had the side effect of allowing creativity to thrive. As I spoke to people who had lived there their whole lives, I would hear wild tales of adventures.

LONDON
UK

London is the city where my story began, and was my home for fifteen years. It was cycling through the spray-painted areas of East London where I fell in love with the old and crumbling buildings and their splashes of colour, flaked and dripping. Commuting to the same photography studio near Old Street, I would often take the route that contained the most interesting urban environment. Day after day, passing the same buildings in Shoreditch, I started to see changes happening. Like watching a plant grow – the difference was imperceptible to fleeting eyes, adamantly staring at their phones and feet as they bustled to their destinations, but over time and with a curious mind for the unusual beauty of the back alleyways and side streets, the differences became obvious. They kept things interesting. New pieces popping up on the walls, another plywood hoarding erected to surround a building – marking it out for development. Old buildings demolished with just the facades remaining – new hotels wearing a mask of history.

The Great Eastern Hotel on Great Eastern Street is one of these buildings. With all but the facade demolished, and a new building erected behind, the developers decided to keep the prominent Stik painting on the side wall. Once a symbol of the affordable area, where art and culture could thrive unhindered, it was now commodified and used to increase the 'cool' factor of the area to investors. These were the very people driving the artists out of the area. Similar artwork can be seen on the hoardings that surround the building. Decorated brightly with murals from a collection of artists, small signs remain, telling people that the space is for commissioned art only. The impression of the area is very different from the heavily curated reality.

Around the corner of the slowly developing Great Eastern Street, the work of Panik appeared, unusual in its strong expression of the worries of a generation. From Dump Trump to Axe the Housing Act, the world was changing around us and there was a rise in the number of protests in the city against Brexit, Trump and the housing crisis, for example. Hopelessness about the future and despair for where we were heading – these were the expressions I expected to find on the walls of my city, but they were distinctly lacking; whitewashed. They only occasionally appeared on my bike route. It felt like the cost of living in London had forced a version of street art and graffiti that was much more about making a name that could have commercial value, rather than about expressing the voice of the voiceless.

This was until Grenfell. The Grenfell Tower fire in 2017 killed an estimated 71 people inside the twenty-four-storey public housing tower block in North Kensington. The fire sent shockwaves across communities in London. There were strong feelings that so many people had died as a result of the social neglect of a whole demographic of the city, the poor and struggling, systematically marginalized by those that should protect them. Not long after the fire, I started noticing the Grenfell tags and throw-ups all over the city – in memory of the victims,

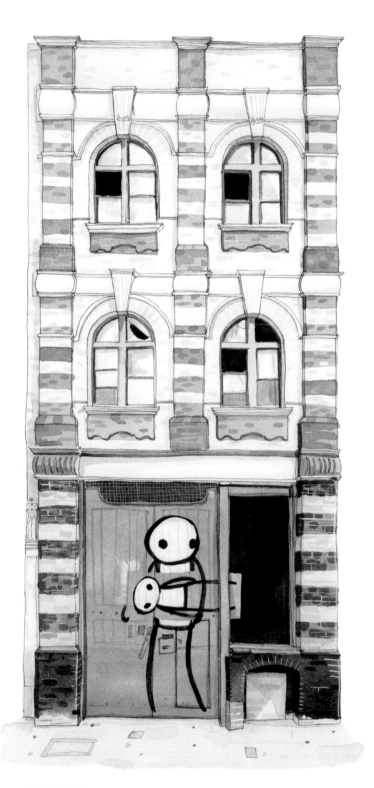

LEFT
41 Pitfield Street, Shoreditch, London. Featuring Stik. Early 2016.

but also as a way of not letting justice for them be brushed aside. The idiom 'Today's front page is tomorrow's chip paper' came to mind. How quickly we forget and move on when living in a place where just keeping your head above water takes so much effort. One of the largest profile pieces talking about this was the Ben Eine mural that used a quote from a poem by Ben Okri: 'You saw it in the eyes of those who survived', painted as part of the Paint The Change project. This project was set up by Maziar Bahari, an Iranian-Canadian journalist and filmmaker, to use street art as a voice for social change – recognizing the power of art in public spaces. The Ben Eine mural lived on the wall from July to October 2017, eventually being buffed ready for a new work, a fortnight after the opening of the Grenfell Tower Inquiry.

Heading further east from Shoreditch into the industrial areas of Hackney, the changes of the city were also tangible.

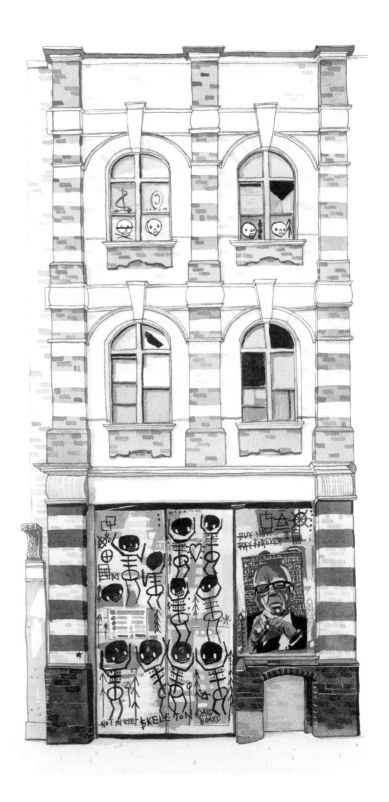

41 Pitfield Street, Shoreditch,
London. Featuring Skeleton
Cardboard and Piicasa. Late
2016.

Having lived in a warehouse in Hackney
Wick in the early 2000s, coming back
fifteen years later the buildings may have
been the same but the atmosphere was
different.

Frontside Gardens, a DIY skate spot built
using reclaimed materials in 2012 by skaters
living in the community on the site of an
old demolished warehouse, had been one
of those spots that I would search the world
for. It was a place where people could be free
and creative. Wrapped in graffitied plywood,
on my first visit I'd circle the brightly
painted tags and 'pieces' hunting for an
entrance. Enticed by the sound of trucks on
coping just out of sight, a full circuit around
the space revealed a box and a large dustbin
that could be scaled to get over the tall fence.
In January 2017 it finally closed for good.
Always intended to be temporary, it marked
another notch on the cycle of development
in an overcrowded city that prioritized the
rich.

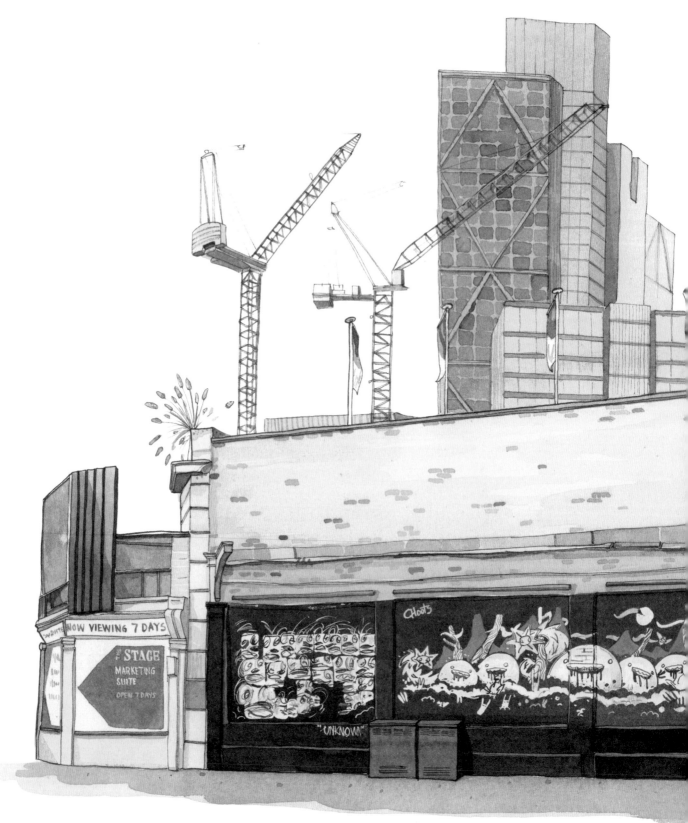

Like watching a plant grow — the difference was imperceptible to fleeting eyes, adamantly staring at their phones and feet as they bustled to their destinations, but over time and with a curious mind for the unusual beauty of the back alleyways and side streets, the differences became obvious.

LEFT
Shoreditch Art Wall, featuring Choots and "Unknown", London.

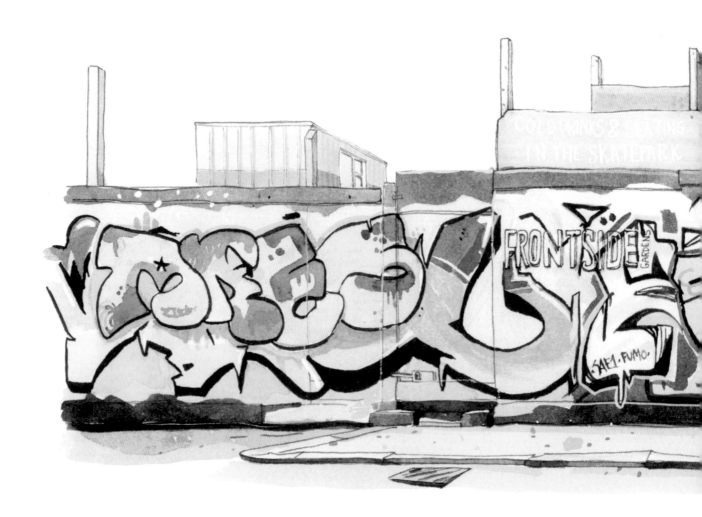

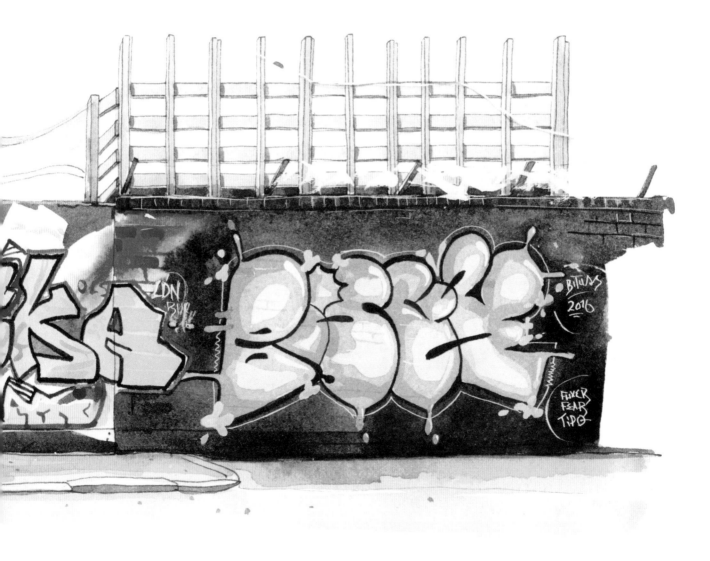

BELOW
Panik, Old Street, London.

RIGHT
Stik, Great Eastern Street
deconstruction, Shoreditch,
London.

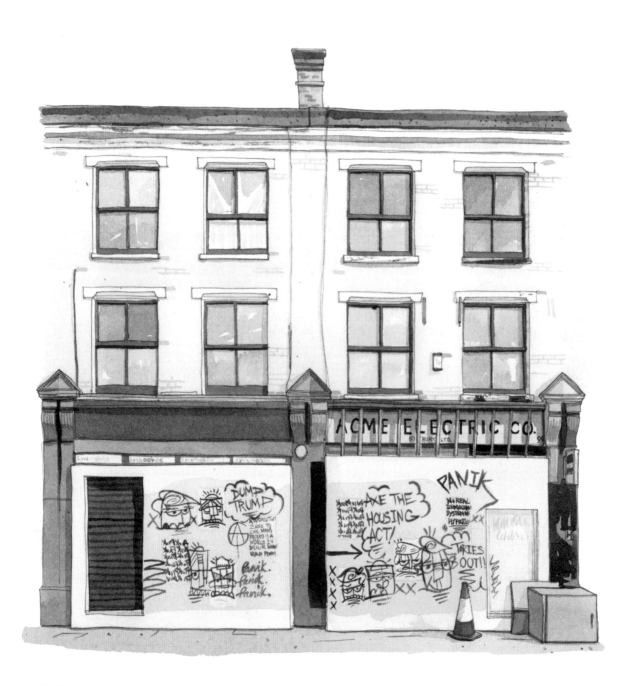

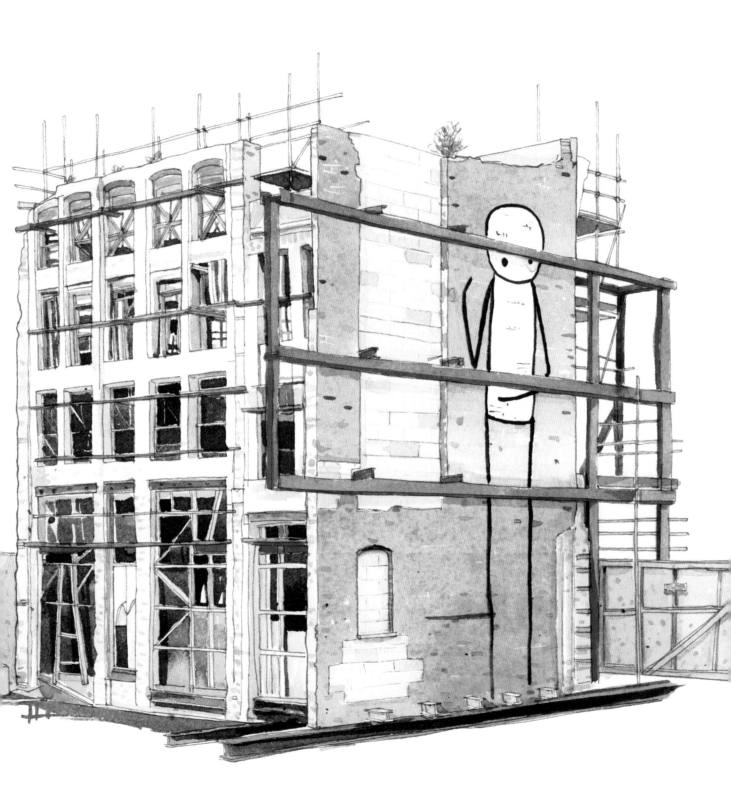

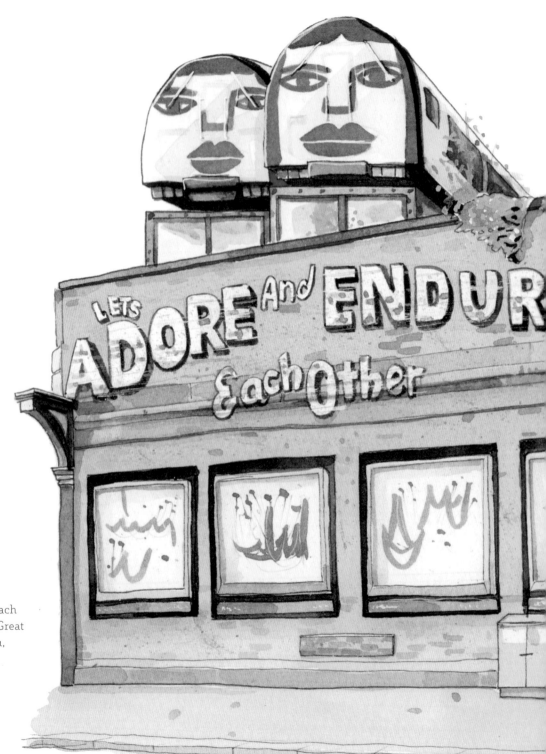

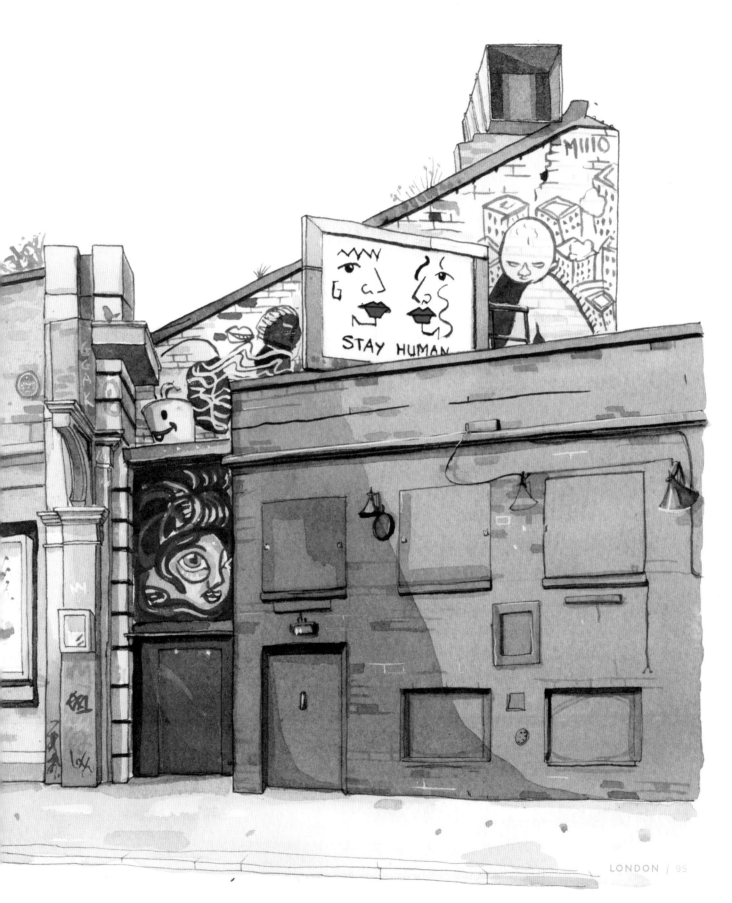

STAY HUMAN

MIIIO

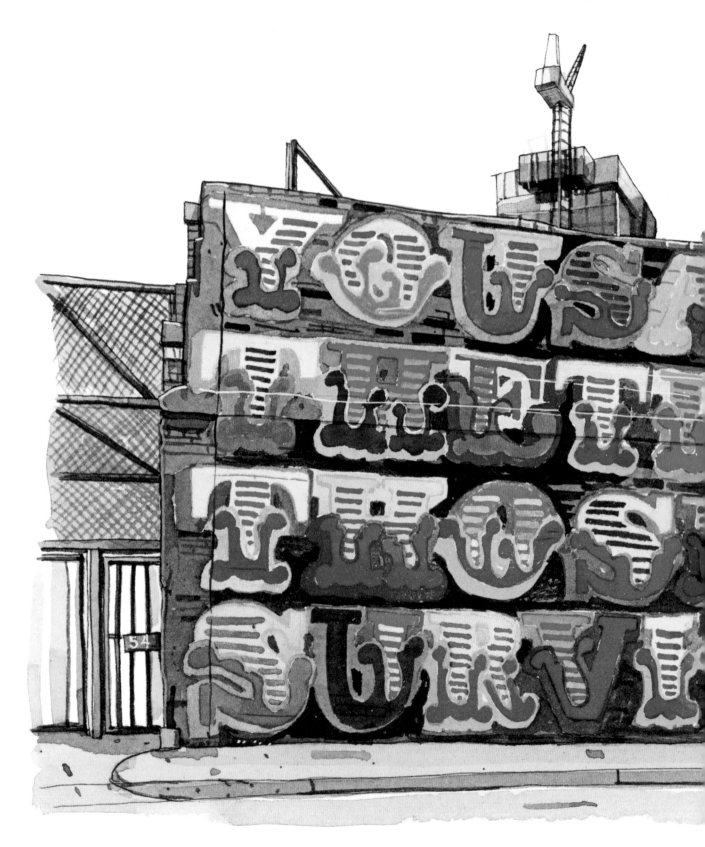

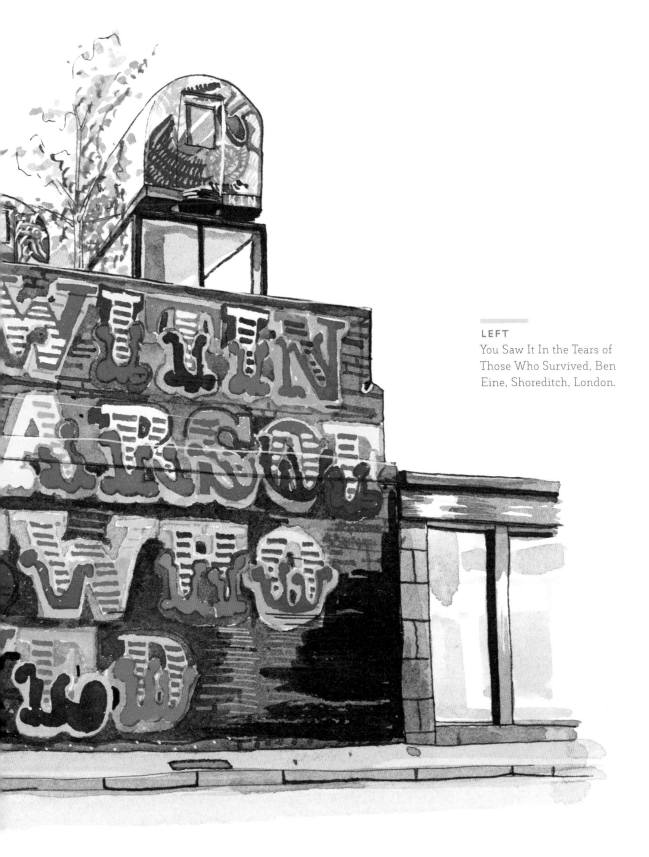

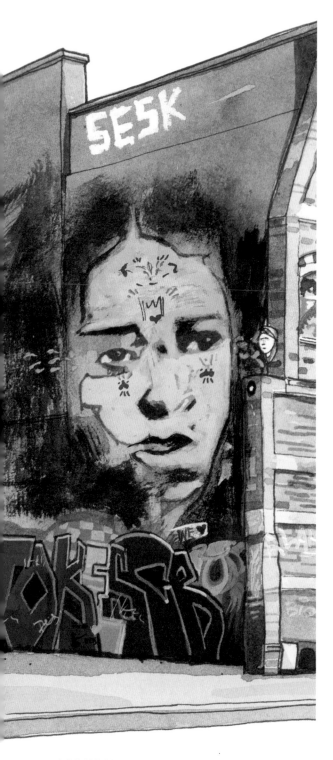

BRISTOL
UK

'Why Bristol?' was the question running through my mind as my train hurtled through the English countryside from London. What made this city of fewer than 500,000 people a hotspot of urban art? It was founded on its harbour, shipping and the slave trade, but its modern economy is comprised of the creative industries, electronics, aerospace, and its two universities. Home to the early works of Banksy, arguably one of the most famous contemporary urban artists in the world, Bristol is also the location of Upfest, an annual street art festival, the largest of its kind in Europe. But what was the catalyst for its unique and often political street art scene? What did Bristol have that other places did not?

I skated the streets of the city looking for clues. It was densely populated and topographically hilly, with diverse architecture that had been constructed through the centuries: a medieval castle, fancy Georgian terraces built from the profits of slavery, Brutalism and extensive rebuilding in the later twentieth century due to the heavy bombing during the Second World War.

What immediately seemed odd as I pushed around the city, was how the street art was not primarily located in the industrial areas or alleyways like so many other cities around the world. Much of it was on the sides of regular houses or on the back-to-back coverings of shops on the high street. The street art was not hidden away but there for everyone to see as they went about their daily lives.

I had arrived in town just after the Upfest Festival had finished, evidence of the 2017 event

painted all over the walls of North Street and the surrounding residential areas. A brand-new Buff Monster piece, 'Something Melty This Way Comes', covered both edges of the Salvation Army community shop on East Street with bright coloured paint. However, I was in time for Dean Lane Hardcore Fun Day, or Deaner Day as it is known locally. This is an annual skateboarding event with music, food and graffiti at the rough and wild skatepark in Dame Emily Park. Held in its current form since 1999, with similar events at the park that could be traced back to the 1980s, it is one of several long-standing community traditions that marked Bristol out from other places. Started by Dylan Lewis and a hardcore group of skaters as an alternative to mainstream skateboarding, holding on to their punk and hardcore music roots, the event was left alone by the police and so the group kept up the tradition. I made myself useful, buffing the surfaces of the ramps in the Dean Lane skatepark ready for fresh graffiti to be sprayed ahead of the Saturday extravaganza. It felt good to be involved in the work for a change, rather than just being an observer. I had forgotten how great it was to feel a part of building something with a group of people. This feeling of creating with others was much more satisfying than just consuming with them.

And what made the city special was the story of the people. Bristol still maintained a thriving underground music and art culture – communities that did not wait for things to happen to them, but rather made things happen, year after year. People who were prepared to put the work into events that celebrated the values that were important to them, not for fame or fortune or worldwide recognition, but to work for the sake of creating something. Music, skateboarding, graffiti and beer.

The fact that I knew so little about Bristol as a city before I arrived highlighted to me that it was its own little microcosm, and this gave people a greater freedom to create what they wanted without much interference from outside. It was also a city that held on tightly to the practical realities of sustaining community. The power of people working together also gave them greater power than people working as individuals – groups of like-minded people are harder to control.

I had heard that the beating heart of the politically active community of Bristol could be found in the Stokes Croft area. Greeted by the huge yellow stencilled face by Columbian artist Stinkfish, painted in 2012, I walked the brightly painted streets. Here, ideas were expressed on the walls without the space to breathe like in other parts of town. The graffiti and street art was layered and mixed together, confusing and loud, like a community meeting where everyone talked over each other because everyone's voice was equally valid. At first glance it was chaotic, but also beautifully democratic and important. Whilst in the area I dropped into Stokes Croft China, a shop run by the People's Republic of Stokes Croft (PRSC), where I talked at length to Chris Chalkley, the Chairman of the PRSC, about how important graffiti and art was to political activity in the city. The vision statement of the PRSC had a strong

emphasis on expressing ideas as a step towards making them a reality; using public art as a way of raising awareness of the things that mattered both within the community and looking out to the world as a whole. Their aim was to constantly and relentlessly question the status quo as a means of improving society. Founded in 2006 when graffiti was being painted stealthily at night and then buffed grey by the council very shortly afterwards, the PRSC worked hard to make public art accepted as a democratic creative expression that should be allowed to thrive. The painting of the Welcome To Stokes Croft mural resulted in the painters being arrested and taken to court. As a result of this incident, there was a U-turn in the response from the authorities to illegal painting on the walls of Stokes Croft. Following this change, the streets slowly filled up with colour.

Of course, I couldn't go on a street art hunt around Bristol without acknowledging Banksy. The first-known large-scale mural by the artist being the 'Mild Mild West' piece in Stokes Croft in 1999, it is believed that Banksy was a product of Bristol's thriving underground arts and culture scene of the 1990s. Banksy is now recognized as – rather ironically given their anonymity – one of the most famous street artists in the world. Their work is a notable catalyst in the shift of how street art has been

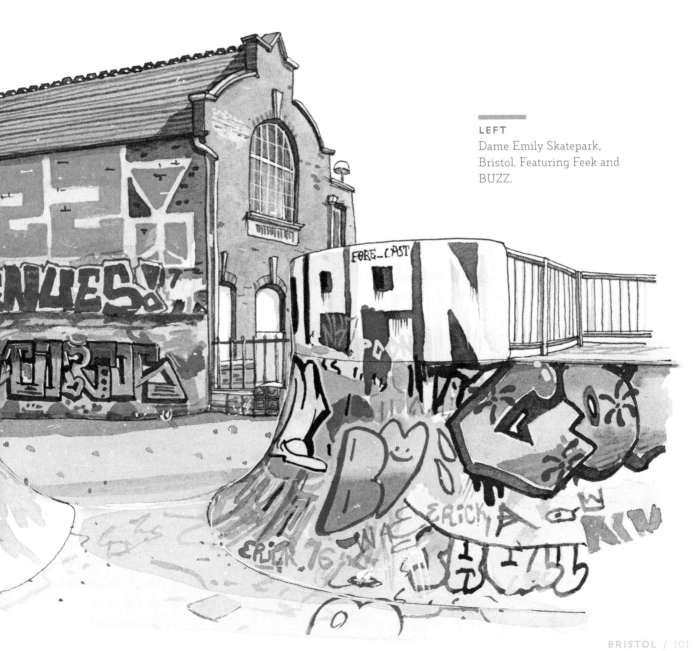

Dame Emily Skatepark,
Bristol. Featuring Feek and
BUZZ.

perceived by the art world over the last decade. I went to find the piece 'The Girl with the Pierced Eardrum' (a parody of 'The Girl with the Pearl Earring' by the painter Vermeer), which was located behind Dockside Studios, a local recording studio, surrounded by industrial buildings. It wasn't the kind of place you just stumble upon whilst taking a leisurely walk around town. As I stood nearby, a number of people came to photograph the piece – many of whom were smartly dressed, travelling in pairs, often middle-aged. A testament to Banksy's ability to appeal to a demographic beyond their peers. In fact, it could be for this reason that 'The Girl with the Pierced Eardrum' was splashed with black paint just twenty-four hours after completion.

Regardless of its popular appeal, Banksy's work is humorous, satirical, political and often has anti-establishment themes that connect with people. Visual epigrams expressed through stencilled paint on walls.

Friends who lived in the city joked to me that they wanted to build a wall to stop more people with average ideas coming in and spoiling their lovely multicultural and vibrant home, watering it down with their unquestioning minds. This idea of keeping it all in brought me back to thoughts of why I had little knowledge of Bristol's unique microcosm before I arrived. So many inspiring things thrived there that never left the city boundaries. People elsewhere didn't know what they were missing out on. Banksy's work took a small part of this out into the world and it resonated with people. It left the city and took a part of the heart of it out into the world, showing the power of ideas expressed on walls to change not only the art world but to shine a light upon the people and communities creating street art. It had elevated the status of street art to something that should be taken seriously, not just a frivolous thing, not just selfish vandalism or 'me, me, me', but rather a reflection of the people and societies making it.

Much of it was on the sides of regular houses or on the back-to-back coverings of shops on the high street. The street art was not hidden away but there for everyone to see as they went about their daily lives.

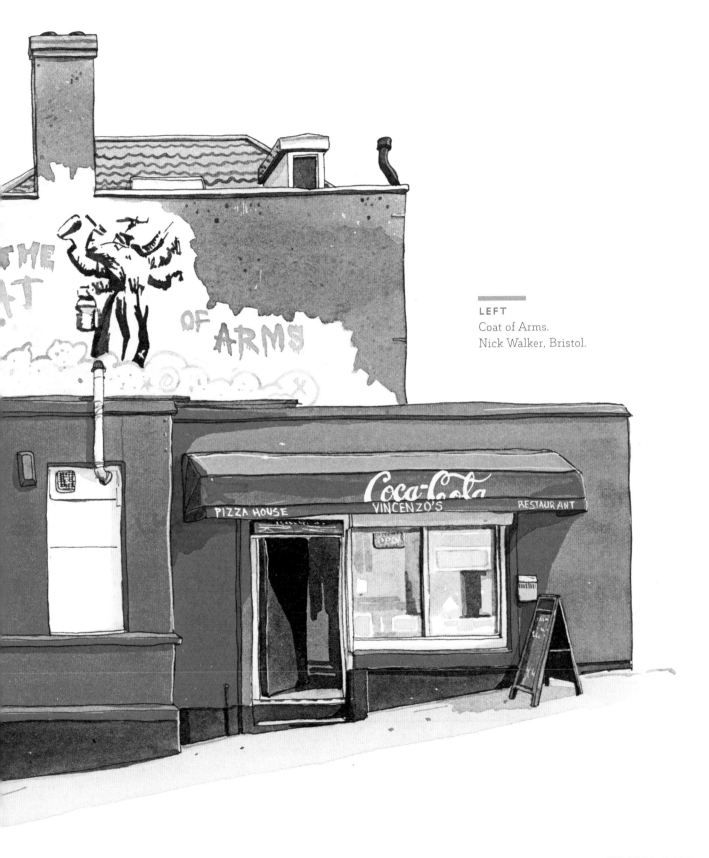

Coat of Arms.
Nick Walker, Bristol.

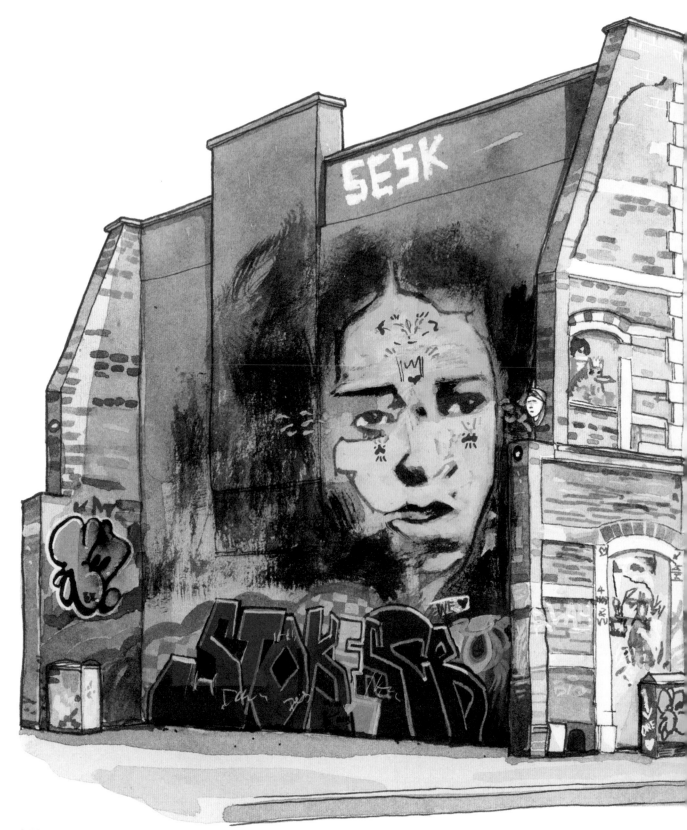

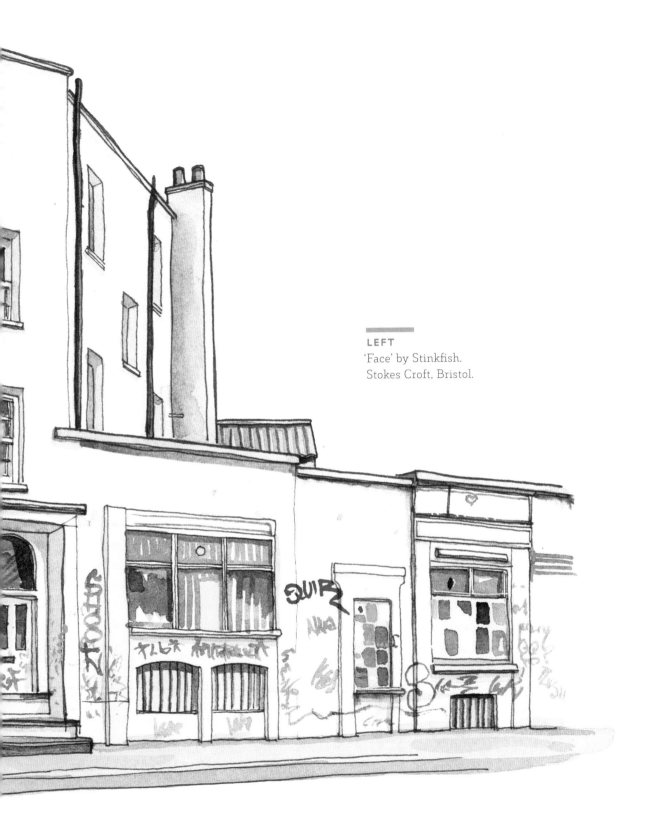

LEFT
'Face' by Stinkfish.
Stokes Croft, Bristol.

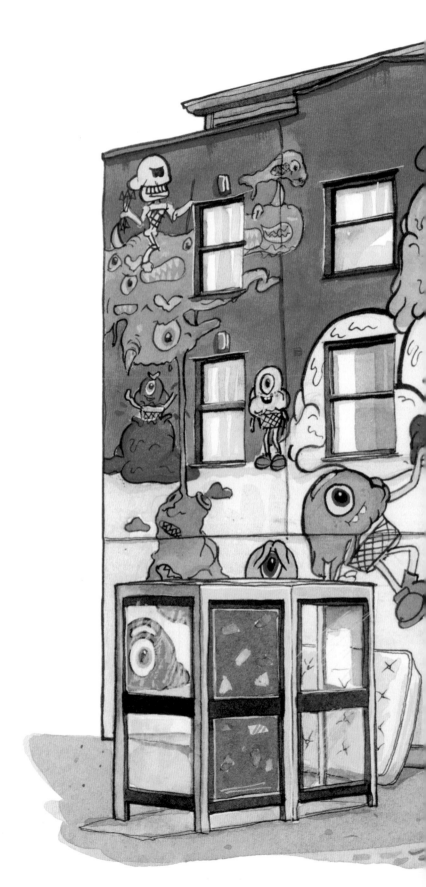

RIGHT
Buff Monster, Church Road,
Bristol.

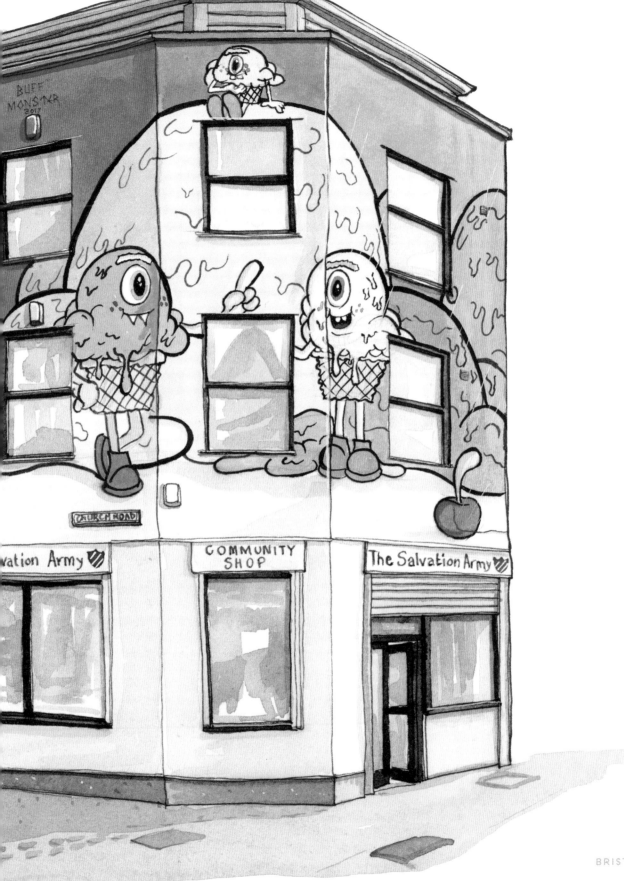

HELSINKI
FINLAND

I had visited friends in Helsinki a few times. My strongest memory was of how grey it was. Tall concrete towers filled with apartments displaying strong influences of modernism and functionalism had created a city that felt quite harsh and lacking in the texture and details that I find so intriguing. It was a city where it seemed that life happened behind the closed doors of the buildings, where the streets were just transit areas. There was a sense that the weather and seasons played a large part in the personality of the city. Winter snow and minimal daylight hours kept people indoors, and long summer days drove them out to the countryside to their summerhouses, to renew beneath canopies of trees and by lakes.

Yet something else was at play here. It was one of those things that you feel but cannot quite explain. The sterile greyness created an unnatural and controlled atmosphere. I just could not find the vibrant back streets that I hunted out in other cities. It was only on researching later that I came across a piece of the city's history that helped me make sense of this feeling. Between 1998 and 2008, the Helsinki Public Works Department launched a 'Stop Clutter' initiative: a zero-tolerance stance on graffiti and street art in the city. Those that broke this new initiative were treated incredibly harshly, and the police and security guards of the city aggressively imposed it. It drove artists underground and out of town. Of course, people still broke those rules, but risking prison and large fines meant that work had to be executed quickly and out of sight.

In 2010, graffiti and street art began to be accepted within designated spaces. A graffiti wall was opened, and became the backdrop to a slowly emerging arts area in the city. Over the following years, a few more legal walls were permitted. Friends would send me photos of the latest work allowed in the city by the likes of Brazilian twins Os Gemeos, and Australian Guido van Helten. Yet there was still something about the control that left it feeling hollow to me, like a city with no flowers growing between cracks in the pavement.

On my last visit, the city had settled at around zero degrees Celsius, and the blanket of snow covering every surface bounced off what little light was coming from the sun, amplifying it. A friend had driven me the forty minutes east of Helsinki to a forest beside a newly developed housing estate. The snow turned muddy and brown where large diggers had churned it up. We walked through the knee-deep snow until we found what we had come for: the abandoned villas. Each building was designed in a different architectural style and scattered around the woodland, surrounded by tall trees that cut out more of the fading sunlight. The story of the village was wrapped in rumour, and nobody I spoke to really knew why it was there and what had happened. The story went that there were plans for a new suburb in the 1970s when all of the houses in this little stretch of woodland were built, but for some reason the redevelopment was abandoned, and therefore so too were the houses. For forty years they sat in the woods by the river, the trees growing up around them, and then through them, each year snowfall and ice putting greater

strain on their weakening structures.

On this visit it was obvious that the degeneration was happening at an accelerated pace both from the environment itself – the blanket of snow being too much weight for the rotten roof timbers to bear any longer – and from arson. Several of the once-grand structures were now just blackened logs and ash on the ground. A camp bed was set up downstairs in one of the buildings that still had a roof. Yet I was saddened to see what looked like asbestos-laced debris scattered around on the floor from the deteriorating structure. It was a reminder of the hidden dangers of old, forgotten structures.

Despite all of this, the whole place was vibrant and rich with colour from the graffiti and murals that covered the remaining walls. The secluded nature of the buildings, worthy of any horror film, had allowed graffiti writers and artists the space to execute their works without being disturbed. In a city as grey as Helsinki, with its long dark winters and grey concrete, this small space in the woods lifted my heart as I explored it. Not just flowers peeking through the cracks, but whole trees.

LEFT
Abandoned villa no. 5.
Helsinki.

RIGHT
Abandoned villa no. 1.
Helsinki.

LEFT
Abandoned villa no. 4.
Helsinki.

RIGHT
Abandoned villa no. 2.
Helsinki.

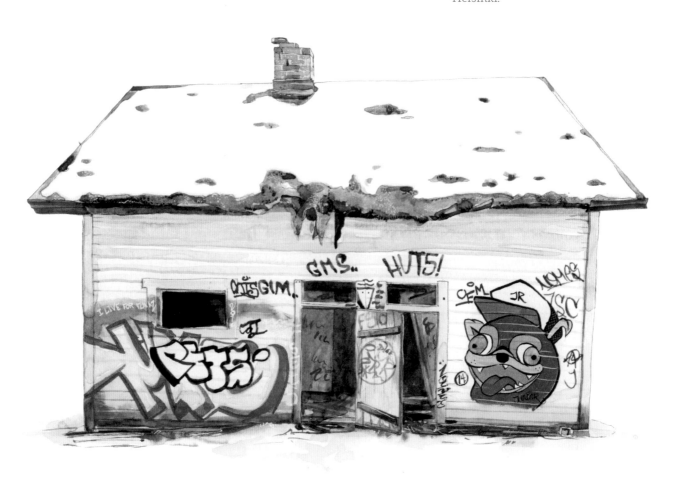

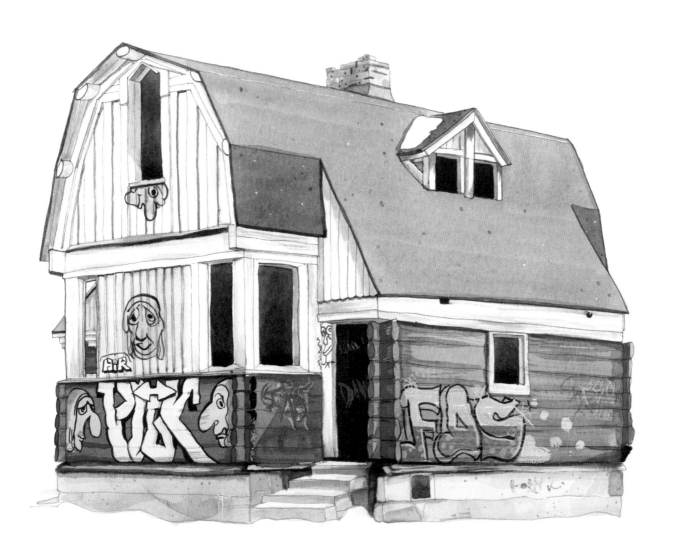

BERLIN
GERMANY

My original plan for Berlin had been to base it around the wall that previously separated East and West Berlin – to paint five sequential pieces of work from the East Side Gallery, a section of the Berlin Wall over a kilometre long that had been turned into an open-air art gallery. I skated along the length of the East Side Gallery, regularly stopping to take in the work. Originally painted in 1990 and featuring the work of over 150 artists, it served as a 'memorial to freedom' and was a direct response to the tearing down of the Berlin Wall in 1989. I had walked lengths of the separation wall in Bethlehem. When in Los Angeles I drove to Tijuana and walked along a few miles of the border fence between Mexico and the USA, in an effort to explore President Trump's assertion that he would build a wall between two places. It felt important that a piece of the Berlin Wall should remain as a reminder, lest we forget how devastating the results of division and separation are to society.

The art on the remaining concrete wall that ran beside the River Spree in Berlin had become part of a changing cycle: painted by the artists, then gradually defaced with accumulating graffiti combined with the natural weathering from the elements, pressure-washed to refresh and clean the surface, then the original artists were invited to repaint their works – some of whom refused. The repainting of the old works gave the whole thing a strange, pastiche feel, and I found what covering the wall in art represented more powerful than a lot of the artwork itself.

It was only on arriving in the city that I realized how much more there was to the place than the wall and the Second World War. How the vibrant, exciting, diverse and active city eclipsed this naïve one-dimensional image of the place that I had carried there. Speaking to local friends, I discovered that the personality of the city had pre-dated the Second World War and the wall completely. From 1900, Berlin was known as a major contributor to the worlds of science, culture, education, government and diplomacy. Its proximity to Poland rendered it culturally diverse. When I mentioned that I was going to Berlin to friends in London, I heard stories of the vibrant culture of the place. The universal personality of the city beyond its role in global history was one of socializing and nightlife.

I found out pretty quickly that time worked differently in this city. Seven p.m. was still classed as afternoon, and midnight as an early bedtime on a weeknight to be ready for work the next day. Even Skatehalle, the indoor skatepark, was open until midnight. It took me a while to get used to the shift in active hours. Walking the streets late at night in the neighbourhood of Neukölln, passing all of the bars sprinkled with people, I felt like I was walking around an Edward Hopper painting. Pools of light illuminated the life, and simultaneously pushed the heavily tagged concrete walls into the shadows. Coloured patches of spray paint added to the mood and texture of the place, especially out of the harsh light of day.

The streets where I was living were covered in tags and throw-ups. Unlike many cities, there seemed to be no requirement to buff the walls, or

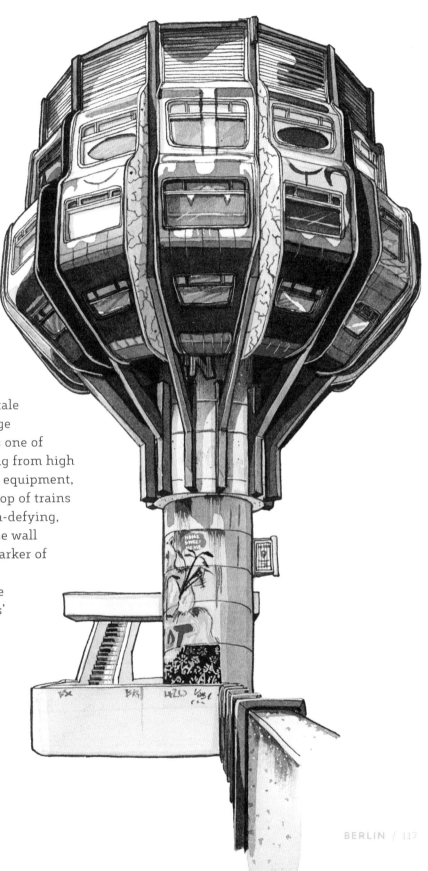

perhaps no power to demand it, so the many layers of names just became part of the character of the streets. As I crossed the bridge over the Spree river, I was intrigued by the blue and red symbols running vertically down a tower. I started to notice these symbols everywhere I went – always in impossible places. They were the work of a graffiti crew called Berlin Kidz, a death-defying group of graffiti writers whose style resembled old fairy-tale lettering, hand-script execution of strange symbols, but whose modus operandi was one of reaching the unreachable. Often abseiling from high windows with the minimum of climbing equipment, the crew were also known for riding on top of trains whilst wearing masks. There was a death-defying, extreme sport aspect that motivated these wall painters – the paint they left behind a marker of where they had been and what they had, hopefully, survived. They produced some of the most extreme versions of 'heavens' graffiti I had seen. The experience and act of creating the work would have eclipsed the work itself had it not been so iconic and unique in its style.

There was a rebellious nature to Berlin. A freedom to be who you wanted to be. The slow rebuilding of the city following the Second World

The many layers of names just became part of the character of the streets.

War, combined with the presence of politically active groups and cooperatives, resulted in a culture of people pulling together to piece their city back together. Following the fall of the Berlin Wall in 1990, a number of large buildings in East Berlin stood empty and the practice of 'instandbesetzen', a mixture of renovating and occupying, grew quickly. These squatted buildings would continue to house groups of like-minded people, often providing different events for the community; the exterior walls of the buildings covered in politically charged messages indicating the uniting beliefs of the people within. I passed one of these buildings when out exploring on my bike, having been disappointed to find that many of the most famous squatted buildings had closed – after decades as community spaces they were now being prepped for development. Kastanienallee 86 displayed the large silver words on the front façade, 'Kapitalismus normiert zerstört tötet' ('Capitalism normalizes, destroys, kills'). There was still life in the building, but the growing number of tidy and expensive shops and restaurants surrounding it were indicative of the increasing pressure it was under from the hand of the developers.

Part way through my trip, my good friend and filmmaker Marta flew in from Portugal for some exploring. We were intoxicated by the feeling of freedom that the city pumped out – such a contrast to London, where CCTV covered every corner and spaces were enthusiastically controlled – I could not believe that the only thing standing between us and our eternal curiosity were a few high barbed-wire fences. We explored the famous abandoned theme park under a blanket of total darkness – shooting long-exposure photographs so we could see what we were standing next to. We climbed into half-demolished buildings, ungracefully hauling ourselves, our cameras and my skateboard out through windows to reach the next floor. On the final day, we found ourselves in what would become my new favourite place in the whole world: an abandoned brewery a little way out of Berlin. Marta rode my bike as I held on to the bike rack, pulled along for miles on my skateboard.

We reached the brewery to find it secured with fences, large quantities of barbed wire and high walls. A few circuits and some ingenuity and resourceful thinking later, we were inside the boundaries and had daylight access to the large number of old industrial buildings, out of view of passers-by. And we were the only ones there. There was brightly painted evidence of other curious visitors who had been before, the external surfaces of the buildings covered in graffiti and murals. Yet nothing could prepare me for the feeling of stepping inside one of the huge buildings. Every room resonated with a different feeling thanks to the unique urban art across the flaking and tumbling walls. As if walking through our own hidden art gallery, we spent hours moving from room to room, building to building. We squeezed through tiny spaces to gain access to more rooms, and an incredible 360-degree view of Berlin from the top of the highest tower. There was nobody curating the work here. It was organically growing

BELOW

Gruppen Stellverretende (left),
Laszlo Erkel (right), East Side
Gallery, Berlin.

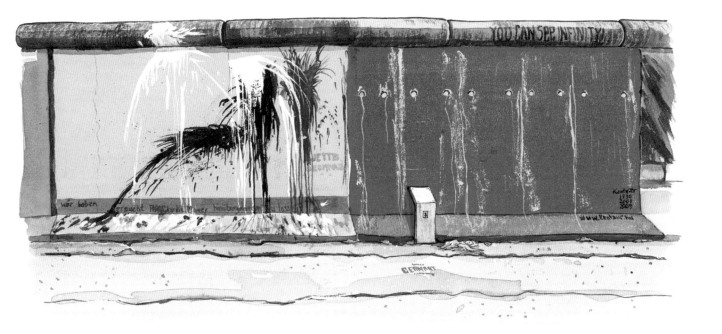

and changing, as anyone with the will to find access and a spray can in their hand could paint undisturbed. I thought about who the audience was; who people were painting for. Something about the place and the work across the walls felt different from regular streets lined with graffiti and murals. It was a place where the art was a purer expression, for the sake of it and the joy of creating it. Not for a large audience or everybody's eyes, instead for their peers and for themselves, and for the occasional curious explorer. Left to their own devices, people had naturally created an environment that was so entrancing to walk around. Like a patchwork quilt handed down from generation to generation, every piece of wall told a different story, expressed by a different person. A perfect reflection of the strange melting pot of Berlin, people mostly left to express themselves as they wished. It was a place I was sad to leave.

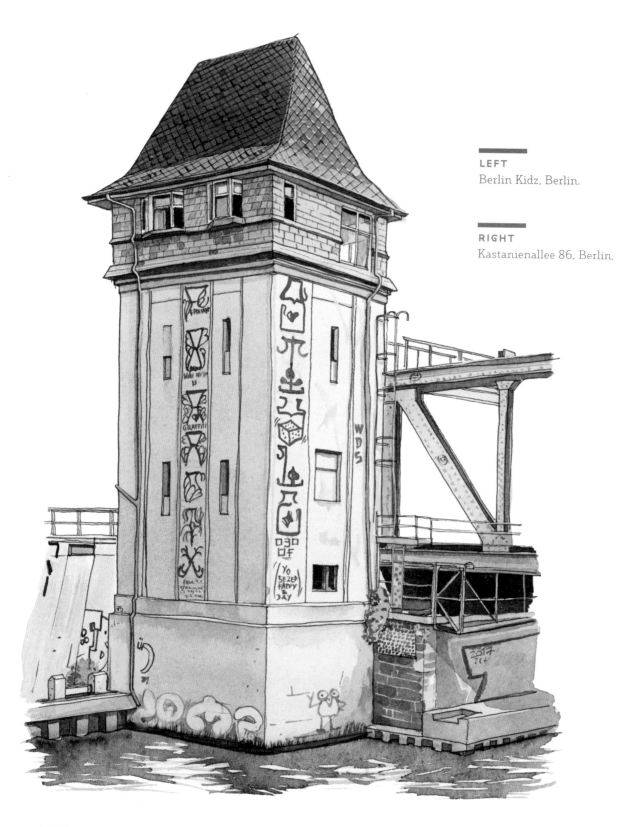

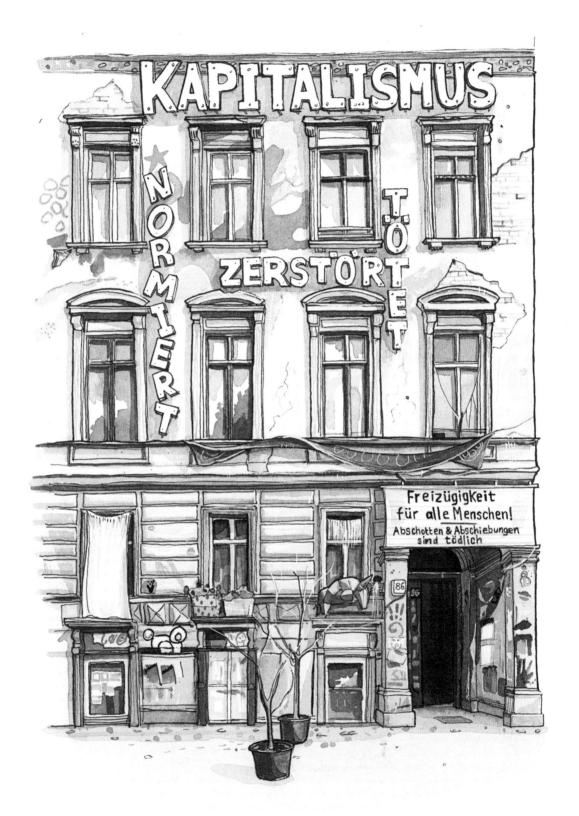

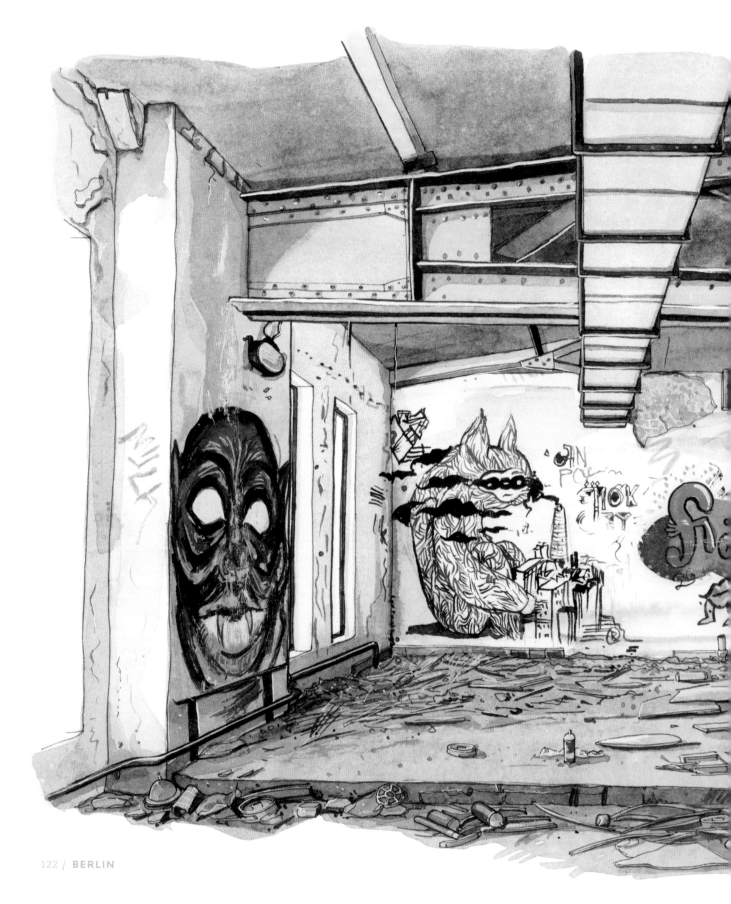

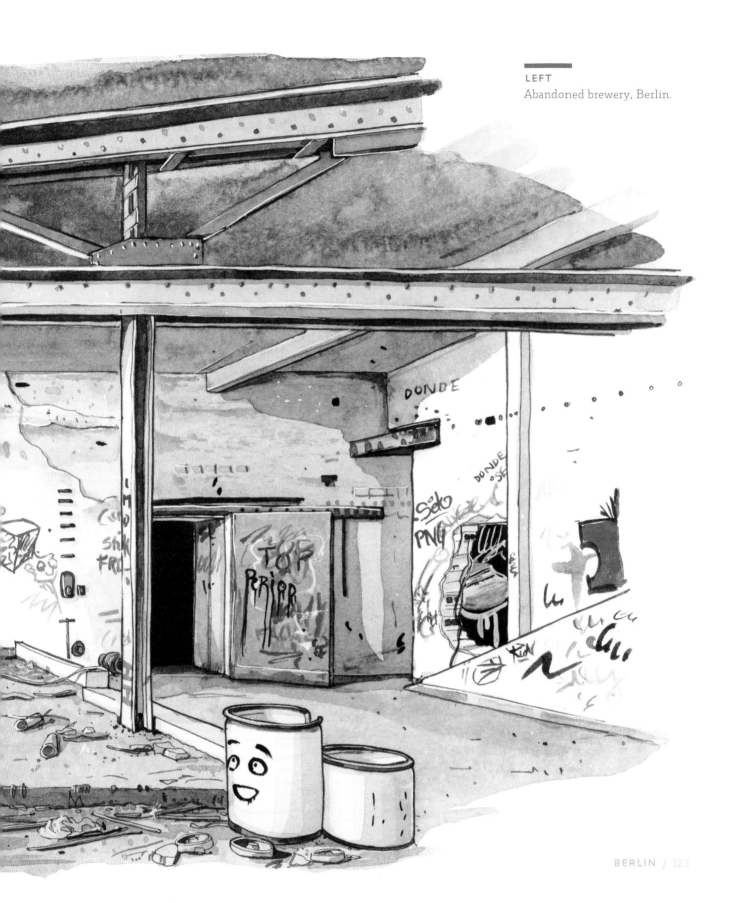

LORNA BROWN

Lorna Brown is a travelling artist exploring the stories of people through their buildings and structures. She studied both technical illustration and scientific and natural history illustration back when pixels were a novelty. Lorna still prefers the feel of paint on paper, constructing images using rulers and pencils. Originally from the UK, she now lives in different places around the world in order to immerse herself in changing communities.

www.lornastration.com